THE CEMETERY OF MEIR

Volume IV

The Tombs of Senbi I and Wekhhotep I

The Australian Centre for Egyptology

A Division of the Macquarie University Ancient Cultures Research Centre

Report 41

THE CEMETERY OF MEIR

Volume IV

The Tombs of Senbi I and Wekhhotep I

Naguib Kanawati and Linda Evans

With contributions by L. Donovan, M. Lashien, A.-L. Mourad,
R. Parker, S. Shafik, A. Suleiman and N. Victor

ISBN: 978-0-85668-847-8

Published in England by: Aris and Phillips Ltd.
Park End Place, Oxford OX1 1HN

CONTENTS

LIST OF PLATES

PREFACE AND ACKNOWLEDGEMENTS

Following the recording and publication of the Old Kingdom tombs located in Sections A and D at Meir, which belonged to the overseers of priests/governors of El-Qusiya, our attention has now shifted to the tombs of their Middle Kingdom successors, located in Sections B and C. The present volume is devoted to tombs B1 and B2, belonging to Senbi I and his son and successor Wekhhotep I. The two tombs contain a wealth of information about the art of the Twelfth Dynasty, with B1 retaining most of its sculpted and painted scenes, and B2, being left unfinished, preserving an unusual amount of its square gridlines, characteristic of the period. The completed scenes in the latter tomb certainly testify to the exceptional ability of its artist(s), which is apparent for instance in the facial details of an emaciated Beja herdsman depicted on the south wall or the eyes of blind harpists shown on the north wall. The desert hunt in both tombs demonstrates originality in the unusual distribution of animals, among which, in B2, are rare depictions of a monkey giving birth and a giraffe.

Despite a thorough investigation of the rock surface inside and around tomb B1, no shafts associated with the tomb were found, a result also reached by earlier excavators at the site. This is extremely curious, as the feature is not restricted to tomb B1, but is also evident in tombs B4 and C1. Only tombs B2 and B3 possess shafts cut into the floors of their chapels, and the latter tomb has, in addition, an external shaft accessed from the mountain surface and descending behind its statue shrine. As the shafts and burial chambers of tomb B2 had been excavated previously, perhaps more than once, our re-clearance did not produce any significant objects, although it enabled us to record all of the tomb's architectural features.

The project at Meir was sponsored by a grant from the Australian Research Council, with additional funding received from the Faculty of Arts, Macquarie University and from the Rundle Foundation for Egyptian Archaeology, for which we are extremely grateful. During our work in Section B of the cemetery we were also afforded great cooperation from the staff of the Ministry of Antiquities. It is a pleasure to acknowledge the support of the successive ministers, Professors Drs Mamdouh El-Damaty and Khaled El-Anany, and to the successive Directors of the Foreign Missions Affairs and Permanent Committee, Dr Mohamed Ismail Khaled and Mr Hany Abu El-Azm. Special thanks are due to the successive Directors General of Antiquities of Asyut, Mr Abdel Sattar Mohamed, and Mr Mahmoud Mahdi, the Director of Antiquities of Asyut north, Mr Ragheb Abdel Hamid, and the Chief Inspector of Antiquities of Meir, Mr Samir Abdul Tawab. Conservation work was required for tomb B2 and we would like to thank Mr Gamal Abdul Malek, Mr Khaled Fawzi Mohamed and Mr Ayman Ismail Abdel Bary from the Conservation Department of the Ministry of Antiquities at Asyut who were responsible for this important task. During our recording of tombs B1 and B2, we were accompanied successively by inspectors, Mr Magdy Samir Sedrak, Mr Sherif Mohamed Mahmoud and Mr Neyaz Mohamed Ali, who went beyond the call of duty to facilitate our task and to provide every assistance.

During the fieldwork and in the preparation of the present volume we were joined by many individuals who should share whatever merit it has. Dr Sameh Shafik was solely responsible for the production of the beautiful and intricate inked drawings of the scenes and inscriptions which adorned the walls of the two chapels, Mr Ahmed Suleiman produced the excellent photographs printed in this volume, frequently working under difficult conditions caused by the present state of the scenes, Mr Naguib Victor recorded the complex architectural features of the tombs and prepared the architectural drawings, and Mr Robert Parker described the tombs' architectural features. In recording the scenes and inscriptions we were helped on site by Dr Miral Lashien, Mr Samir Abdul Tawab, Mr Tareq Roweish, and Mrs Abeer Antar. Dr Anna-Latifa Mourad prepared the final plates for publication and Mrs Leonie Donovan prepared the final document for printing; Dr Joyce Swinton and Ms Natasha Baramalis provided valuable editorial help. We offer our deep thanks and appreciation to everyone who took part in the project.

Naguib Kanawati and Linda Evans

ABBREVIATIONS

Altenmüller, *Mehu*: Altenmüller, H., *Die Wanddarstellungen im Grab des Mehu in Saqqara* (Mainz am Rhein, 1998).

BACE: *Bulletin of the Australian Centre for Egyptology.*

BIFAO: *Bulletin de l'Institut français d'archéologie orientale, Le Caire.*

Barta, *Opferliste*: Barta, W., *Die altägyptische Opferliste, von der Frühzeit bis zur griechisch-römischen Epoche* (Berlin, 1963).

Blackman, *Meir*: Blackman, A. M., *The Rock Tombs of Meir*, 6 vols. (London, 1914-53).

Borchardt, *Saȝḥu-Reᶜ*: Borchardt, L., *Das Grabdenkmal des Königs Saȝḥu-Reᶜ*, 3 vols. (Leipzig, 1910-13).

Brewer and Friedman, *Fish and Fishing*: Brewer, D. J. – Friedman, R. F., *Fish and Fishing in Ancient Egypt* (Warminster, 1989).

Brewer et al., *Domestic Plants*: Brewer, D. J. – Redford, D. B. – Redford, S., *Domestic Plants and Animals: The Egyptian Origins* (Warminster, 1994).

BSEG: *Bulletin de la Societe d'Égyptologie de Genève.*

Davies, *Antefoqer*: Davies, N. de G., *The Tomb of Antefoqer, Vizier of Sesostris I, and of his Wife, Senet [No. 60]* (London, 1920).

Davies, *Deir el-Gebrâwi*: Davies, N. de G., *The Rock Tombs of Deir el-Gebrâwi*, 2 vols. (London, 1902).

Davies, *Ptahhetep*: Davies, N. de G., *The Mastaba of Ptahhetep and Akhethetep at Saqqareh* (London, 1900).

De Morgan, *Catalogue des monuments*: De Morgan, J., *Catalogue des monuments et inscriptions de l'Égypte antique* 1 (Vienna, 1894).

Duell, *Mereruka*: Duell, P., *The Mastaba of Mereruka*, 2 vols. (Chicago, 1938).

Edel, Qubbet el-Hawa I: Edel, E., *Die Felsengräbernekropole der Qubbet el-Hawa bei Assuan*, 3 parts. (Paderborn, 2008).

Erman and Grapow, *Wörterbuch*: Erman, A. – Grapow, H., *Wörterbuch der ägyptischen Sprache*, 6 vols. (Leipzig, 1925-50).

Estes, *Behavior Guide*: Estes, R. D., *The Behavior Guide to African Mammals: Including Hoofed Mammals, Carnivores, Primates* (Berkeley, 1991).

Evans, *Animal Behaviour*: Evans, L., *Animal Behaviour in Egyptian Art: Representations of the Natural World in Memphite Tomb Scenes* (Oxford, 2010).

Faulkner, *Dictionary*: Faulkner, R. O., *A Concise Dictionary of Middle Egyptian* (Oxford, 1962).

Favry, *Le nomarque*: Favry, N., *Le nomarque sous le règne de Sésostris Ier* (Paris, 2005).

Gamer-Wallert, *Fische und Fischkulte*: Gamer-Wallert, I., *Fische und Fischkulte im alten Ägypten* (Wiesbaden, 1970).

GM: *Göttinger Miszellen.*

Grajetzki, *Court Officials*: Grajetzki, W., *Court Officials of the Egyptian Middle Kingdom* (London, 2009).

Hannig, *Wörterbuch*: Hannig, R., *Ägyptisches Wörterbuch* I: *Altes Reich und Erste Zwischenzeit* (Mainz am Rhein, 2003).

Harpur, *Decoration*: Harpur, Y., *Decoration in Egyptian Tombs of the Old Kingdom: Studies in Orientation and Scene Content* (London, 1987).

Harpur, *Maidum*: Harpur, Y., *The Tombs of Nefermaat and Rahotep at Maidum* (Oxford, 2001).

Harpur and Scremin, *Ptahhotep*: Harpur, Y. – Scremin, P., *The Chapel of Ptahhotep, Scene Details* (Oxford, 2008).

Hassan, *Gîza*: Hassan, S., *Excavations at Gîza,* 10 vols. (Oxford and Cairo, 1929-1960).

Horm. Behav.: *Hormones and Behaviour*

Houlihan, *Birds*: Houlihan, P. F., *The Birds of Ancient Egypt* (Warminster, 1986).

J. Lepid. Soc.: *Journal of the Lepidopterists' Society.*

JEA: *Journal of Egyptian Archaeology.*

Jéquier, *Neit et Apouit*: Jéquier, G., *Les pyramides des reines Neit et Apouit* (Cairo, 1933).

Jéquier, *Oudjebten*: Jéquier, G., *La pyramide d'Oudjebten* (Cairo, 1928).

Jones, *Index*: Jones, D., *An Index of Ancient Egyptian Titles, Epithets and Phrases of the Old Kingdom* (Oxford, 2000).

Kanawati, *Deir el-Gebrawi 2*: Kanawati, N., *Deir el-Gebrawi*, vol. 2: *The Southern Cliff. The Tomb of Ibi and Others* (Oxford, 2008).

Kanawati, *Deir el-Gebrawi* 3: Kanawati, N., *Deir el-Gebrawi*, vol. 3: *The Southern Cliff. The Tomb of Djau/Shemai and Djau* (Oxford, 2013).

Kanawati, *El-Hawawish* 1: Kanawati. N., *The Rock Tombs of El-Hawawish: The Cemetery of Akhmim*, vol. 1. (Sydney, 1980).

Kanawati, *Meir* 1: Kanawati, N., *The Cemetery of Meir*, vol. 1: *The Tomb of Pepyankh the Middle* (Oxford, 2012).

Kanawati, *Teti Cemetery* 8: Kanawati, N., *The Teti Cemetery at Saqqara*, vol. 8: *The Tomb of Inumin* (Oxford, 2006).

Kanawati and Abder-Raziq, *Mereruka and His Family* 1: Kanawati, N. – Abder-Raziq, M., *Mereruka and His Family*, Part 1, *The Tomb of Meryteti* (Oxford, 2004).

Kanawati and Abder-Raziq, *Unis Cemetery* 2: Kanawati, N. – Abder-Raziq, *The Unis Cemetery at Saqqara*, vol. 2: *The Tombs of Iynefert and Ihy (reused by Idut)* (Oxford, 2003).

Kanawati and Evans, *Meir* 2: Kanawati, N. – Evans, L., *The Cemetery of Meir*, vol. 2: *The Tomb of Pepyankh the Black* (Oxford, 2014).

Kanawati and Evans, *Beni Hassan* 1: Kanawati, N. – Evans, L., *Beni Hassan*, vol. 1: *The Tomb of Khnumhotep II* (Oxford, 2014)

Kanawati and Evans, *Beni Hassan* 3: Kanawati, N. – Evans, L., *Beni Hassan*, vol. 3: *The Tomb of Amenemhat* (Oxford, 2016).

Kanawati and Woods, *Beni Hassan*: Kanawati, N. – Woods, A., *Beni Hassan: Art and Daily Life in an Egyptian Province* (Cairo, 2010).

Kanawati et al., *Teti Cemetery* 3: Kanawati, N. – Abder-Raziq, M. – McFarlane, A. – Thompson, E. – Shafik, S., *The Teti Cemetery at Saqqara*, vol. 3: *The Tombs of Neferseshemre and Seankhuiptah* (Warminster, 1998).

Kanawati et al., *Mereruka and His Family* 3:1: Kanawati, N. – Woods, A. – Shafik, S. – Alexakis, E., *Mereruka and His Family*, Part 3:1, *The Tomb of Mereruka* (Oxford, 2010).

Lashien, *Kahai*: Lashien, M., *The Chapel of Kahai and his Family* (Oxford, 2013).

Lepsius, *Denkmäler*: Lepsius, K. R., *Denkmäler aus Äegypten und Äthiopien*, 12 vols. (Berlin, 1849-58); Ergänzungsband (Leipzig, 1913).

MDAIK: *Mitteilungen des Deutschen Archäologischen Institutes, Abteilung Kairo.*

Montet, *Vie privée*: Montet, P., *Scènes de la vie privée dans les tombeaux égyptiens de l'Ancien Empire* (Paris, 1925).

Mourad, *The Hyksos*: Mourad, A.-L., *Rise of the Hyksos: Egypt and the Levant from the Middle Kingdom to the Early Second Intermediate Period* (Oxford, 2015).

Moussa and Altenmüller, *Nianchchnum*: Moussa, A. M. – Altenmüller, H., *Das Grab des Nianchchnum und Chnuhotep* (Mainz am Rhein, 1977).

Murray, *Saqqara Mastabas* 1: Murray, M. A., *Saqqara Mastabas*, vol. 1 (London, 1905).

Newberry, *Beni Hasan*: Newberry, P. E., *Beni Hasan*, 4 vols. (London, 1893-1900).

Newberry, *El-Bersheh*: Newberry, P. E., *El-Bersheh*, 3 vols. (London, 1894-96).

Osborn and Osbornová, *Mammals*: Osborn, D. J. – Osbornová, J., *The Mammals of Ancient Egypt* (Warminster, 1998).

Petrie, *Dendereh*: Petrie, W. M. F., *Dendereh 1898* (London, 1900).

Ranke, *Personennamen*: Ranke, H., *Die ägyptischen Personennamen*, 3 vols. (Glückstadt, 1935-77).

Schäfer, *Principles of Egyptian Art*: Schäfer, H., *Principles of Egyptian Art*, Baines, J., trans. (Oxford, 1974).

Siebels, *Agriculture*: Siebels, R., *Agriculture in Old Kingdom Tomb Decoration: An Analysis of Scenes and Inscriptions* (PhD Thesis, Macquarie University, Sydney, 2000).

Smith, *HESPOK*: Smith, W. S., *A History of Egyptian Sculpture and Painting in the Old Kingdom* (London, 1978).

Stoof, *Hasendarstellungen*: Stoof, M., *Hasendarstellungen im alten Ägypten* (Hamburg, 2005).

Strandberg, *The Gazelle*: Strandberg, A., *The Gazelle in Ancient Egyptian Art: Image and Meaning* (Uppsala, 2009).

Swinton, *Management of Estates*: Swinton, J., *The Management of Estates and their Resources in the Egyptian Old Kingdom* (Oxford, 2012).

TMO: *Travaux de la Maison de l'Orient.*

Vandier, *Manuel*: Vandier, J., *Manuel d'archéologie égyptienne*, 6 vols. (Paris, 1952-78).

Varille, *Ni-ankh-Pepi*: Varille, A., *La tombe de Ni-ankh-Pepi à Zâouiyet el-Mayetîn* (Cairo, 1938).

Vernus and Yoyotte, *Bestiare*: Vernus, P. – Yoyotte, J., *Bestiare des Pharaons* (Paris, 2005).

Ward, *Index*: Ward, W. A., *Index of Egyptian Administrative and Religious Titles of the Middle Kingdom* (Beirut, 1982).

Wild, *Ti* 2: Wild, H., *Le tombeau de Ti*, Fascicle 2 (Cairo, 1953).

THE TOMB OF SENBI I
No. B1

I THE TOMB OWNER, HIS FAMILY AND DEPENDENTS

The Tomb Owner

NAME

Snb.j[1] 'Senbi'.

TITLES

1- *jmj-r ḥmw-nṯr* 'overseer of priests'.[2]
2- *jrj-pʿt* 'hereditary prince'.[3]
3- *ḥȝtj-ʿ* 'count'.[4]
4- *ḫtmtj-bjtj* 'sealer of the king of Lower Egypt'.[5]
5- *ẖrj-ḥbt ḥrj-tp* 'chief lector priest'.[6]
6- *smr wʿtj* 'sole companion'.[7]

Wife of Senbi

NAME

Mr.s[8] 'Meres'. Senbi's wife is represented with him on three occasions: she accompanies him during his spear fishing and fowling trips, and also when they receive offerings from bearers, where she is designated as *jmȝẖjjt pr ḥmwt* 'the honoured one of the house of women/ wives'.[9] This epithet is perhaps similar to that of *ḥnwt ḥmwt nbwt* 'mistress of all women/ wives' held by *Sȝt-jp* 'Satip', wife of Khnumhotep I (no. 14) of Beni Hassan.[10] Both epithets thus hint at the existence of many wives or a harem, even though only one is represented in the tomb.

[1] Ranke, *Personennamen* 1, 313:23.
[2] Ward, *Index*, 35(259); Jones, *Index*, 171[651].
[3] Ward, *Index*, 102(850); Jones, *Index*, 315[1157].
[4] Ward, *Index*, 104(864); Jones, *Index*, 496[1858].
[5] Ward, *Index*, 170(1472), where it is read as *sḏȝw.ty bi.ty*; Jones, *Index*, 763[2775].
[6] Ward, *Index*, 126(1076); Jones, *Index*, 784[2860].
[7] Ward, *Index*, 151(1299); Jones, *Index*, 892[3268].
[8] Ranke, *Personennamen* 1, 158:5.
[9] Blackman's reading of the name as '*Per-Hemut-meres*' 'The Ḥarîm is her lover' (*Meir* 1, 11 n. 3, 19) seems unlikely, and the name is unattested in Ranke's work. This appears to be an epithet for Meres.
[10] Newberry, *Beni Hasan* 1, pl. 46. For the reading of the epithet see Ward, *Index*, 115.

Father of Senbi

NAME

Wḫw-ḥtp(.w)[11] 'Wekhhotep'. Nothing is known about Senbi's background except that his father was called *Wḫw-ḥtp(.w)*. 'Wekhhotep'[12] is a name that, like many others at El-Qusiya, is formed with the Wekh-fetish of Hathor[13] and was held by later members of the family.

Son of Senbi

NAME

Wḫw-ḥtp(.w) 'Wekhhotep'. No figure or name of the son is preserved in the tomb, but the fact that the owner of the adjacent tomb, B2, is called Wekhhotep, son of Senbi,[14] suggests strongly that he was the child of the owner of tomb B1.

Dependents of Senbi

1- *ʿnḫ.j*[15] 'Ankhi'. *sm* 'sm-priest'.[16]
1- *Nṯrw-ḥtp(.w)*[17] 'Netjeruhotep'. *jmj-r ʿḫnwtj* 'chamberlain'.[18]
2- *Ḥnmw*[19] 'Khnum'. *jmj-r pr* 'overseer of the house'.[20]

Unnamed Dependents of Senbi

2- *jmj-r rḫtjw* 'overseer of washermen'.[21]
3- *jrj mrḥt* 'keeper of salve'.[22]
4- *wt(j)* 'embalmer'.[23]
5- *smr* 'companion'.[24]
6- *ẖrj-ḥbt* 'lector priest'.[25]

[11] Ranke, *Personennamen* 1, 84:9.
[12] Blackman, *Meir* 1, pl. 9.
[13] For details, see Blackman, *Meir* 1, 3-4.
[14] Blackman, *Meir* 2, pls. 8, 10-12, 15.
[15] Ranke, *Personennamen* 1, 68:3.
[16] Ward, *Index*, 168(1465); Jones, *Index*, 885[3241]. The reading *stm* is also possible.
[17] Ranke, *Personennamen* 1, 214:27.
[18] Ward, *Index*, 14(72).
[19] Ranke, *Personennamen* 1, 275:5.
[20] Ward, *Index*, 21(132); Jones, *Index*, 114[461].
[21] Ward, *Index*, 33(238); Jones, *Index*, 160[615].
[22] Ward, *Index*, 64(519).
[23] Ward, *Index*, 90(754); Jones, *Index*, 405[1492]].
[24] Jones, *Index*, 891(3263).
[25] Ward, *Index*, 140(1202); Jones, *Index*, 781[2848].

II THE DATE OF SENBI I

Senbi is the first known nomarch, or indeed overseer of priests, to have governed the Fourteenth Upper Egyptian province in the Middle Kingdom, most probably early in the Twelfth Dynasty.[26] No cartouche of any king is recorded in Senbi's tomb, but a date under Amenemhat I[27] or Senwosret I[28] has been suggested, and it appears that the latter reign saw the appointment of other powerful and trustworthy individuals in certain provinces.[29] The date for Senbi can only be tentative, as the absence of royal names is not limited to his tomb but is found in five out of the six Middle Kingdom decorated tombs (A3, B1, B2, B3, B4, C1). The only tomb containing royal cartouches is that of Wekhhotep II (B4), where on the lintel above the statue recess and immediately opposite the entrance to the chapel the cartouches of the king of Upper and Lower Egypt, Nubkaure and the son of Re Amenemhat are inscribed.[30] There can be little doubt that tomb B4 was decorated under Amenemhat II, but whether this took place early or late in the reign is unknown.

Senbi I was succeeded by Wekhhotep I of tomb B2, who was followed by Senbi II of tomb B3, before Wekhhotep II of B4 was placed in charge of the province. It is important to note, however, that the preparation of both B2 and B3 came to a sudden halt, most probably due to the early death of their owners. After preparing the walls for decoration in tomb B2, square gridlines were drawn and scenes and inscriptions were added in black outline before the sculptors began carving the reliefs on different parts of the walls, but the work was eventually abandoned in various stages of completion. Some wall sections retain only a square grid and drawings, while carving is partly achieved in others. Colours are only added in the statue recess and, with the exception of the excellent grids and drawings of figures and hieroglyphs, the evidence suggests that the sculptors were working very quickly. Tomb B3 is even less complete, with parts of the floor uneven, shaft 2 achieving a depth of 19 metres deep but without a burial chamber being cut, and the walls of the chapel failing to be smoothed. Decoration is limited to the jambs and lintel of the entrance to room 2 and to two small and hastily executed false doors belonging to Senbi and his sister Mersi.

We do not know how late in Amenemhat II's reign Wekhhotep II prepared tomb B4. The unfinished condition of tombs B2 and B3 also seems to indicate that their owners did not occupy the governorship, or indeed the office of overseer of priests in the province, for a long period. It seems most likely then that Senbi I (B1) and Wekhhotep I (B2) should both be dated to the long reign of Senwosret I,[31] with the remote possibility of dating the former to the reign of Amenemhat I.

Suggested date: Reign of Senwosret I.

[26] Blackman, *Meir* 1, 11.
[27] Grajetzki, *Court Officials*, 113.
[28] Favry, *Le nomarque*, 307.
[29] Favry, *Le nomarque*, 307.
[30] Blackman, *Meir* 3, pl. 19.
[31] Favry, *Le nomarque*, 38, 307.

III ARCHITECTURAL FEATURES

Pls. 1-2, 73

The rock-cut tomb of *Snbj* (B1) is the northernmost of the decorated tomb-chapels of the Dynasty 12 nomarchs. It comprises an almost square chapel with a shrine accessed via a central sunken pathway. Tomb B1 has a south-easterly aspect and is approached by a small forecourt formed by cutting back the rock slope by 3.23m and .67cm on the southern and northern sides respectively. The forecourt's western side forms the chapel façade, which measures .77m on the southern side and .71m on the northern side of the doorway. Although the façade is badly preserved, it appears to have been smooth and undecorated originally.

The entrance to the chapel is cut into the centre of the façade and is approached by a broad step up, 2.42m N-S x .20m E-W x .15m high. The doorway is .94m wide x .58m thick; as the lintel is missing, the original door height is unknown. What remains of the original exterior door jamb is 1.20m high and the internal door jamb is 1.76m in height. A .92m long x .03m deep groove is cut in the floor parallel to the doorway step together with a .30m wide pivot hole at its southern end, making the groove and pivot hole slightly longer than the doorway width. It is unknown if a reciprocal pivot hole existed in the ceiling as the NW and SW corners of the chapel are the only extant areas of ceiling.

The chapel is divided into two almost equal areas by a sunken pathway 5.94m long x 1.38m wide that runs along the central axis from the chapel entrance to the shrine on the western wall. The pathway rises from .35m below floor level at the entrance via two ascending steps, the first with a .29m tread width x .10m rise and the second with a .07m rise. From the top step to the shrine measures 4.44m, the latter rising by a broad step of .66m tread width x .04m rise; the level shrine floor is a further .07m high. On the south side of the pathway the chapel floor is 7.57m long x 3.10m wide, and on the northern side 7.57m to 7.17m long x 3.12m wide (the length difference is caused by the NW corner being left unfinished). The E-W longitudinal axis is 0.21m longer than the N-S transverse axis.

The focal point of the chapel is the shrine, which projects .96m into the chapel from the centre of the western wall. The shrine measures 1.10m N-S x .96m E-W with an internal recess .40m N-S x .59m E-W x 1.00m high. On the northern side of the inner shrine architrave is a socket indicating that a door was once in place, however due to the poor stone quality the threshold is not well preserved. The shrine is painted inside and out to imitate pink granite. There is a Coptic cross painted on the south side. Above the entrance to the shrine is a cavetto cornice, while a torus-roll runs beneath the cornice and down either side of the doorway. In the area between the torus-roll and cornice as well as on both sides of the entrance are incised inscriptions, which are painted blue. There is no evidence of engaged statuary, suggesting that if a figure of the tomb owner was kept here, it was portable.

All the chapel walls were decorated with scenes rendered in painted relief, with the exception of the western wall, which was left unfinished. The eastern wall, while decorated, has received extensive damage. Owing to lack of preservation, the western wall height of 2.23m is the only wall that can be measured with certainty.

Cut into the floor of the chapel are four squarish shaped pits, one at each corner. All but one has a .04m to .06m wide x .05m deep lip running around each side, possibly so that the pit could be covered. At the N-E corner, located .06m from the north wall and .04m from the east wall, the pit measures .40m N-S x .41m E-W x .40m deep. This pit has only one .06m wide lip on its northern edge. At the S-E corner, the pit is situated .09m from both the east and south walls. It measures .34m N-S x .35m E-W, but the lips reduce the internal measurements to .25m N-S x .26m E-W x .30m deep. In the S-W corner, the pit is .14m from the south wall and .21m from the west wall. It measures .35m N-S x .34m E-W, with the four lips again reducing the internal measurements to .27m N-S x .26m E-W x .15m deep. The N-W corner of the chapel is unfinished, however the pit located here is cut at a S-W diagonal. Its dimensions are .33m N-S x .34m E-W, with the four lips reducing the internal pit size to .25m x .25m x .23m deep.

A further pit, conical in shape and measuring .35m diameter x .40m deep, is located in the northern floor section. Measured from its centre, it is cut 1.48m from the chapel's north wall and 4.20m from the eastern wall.

The chapel and forecourt contain no visible burial shafts.

IV SCENES AND INSCRIPTIONS

The Chapel

Although work on the decoration of the north, east, and south walls appears to have been completed, the west wall was left blank and in a rough condition, presumably due to encountering poor rock formation and large fissures. The rather flat slant of the cliff in section B of the cemetery necessitated the cutting of tombs with low ceilings, which were also formed of relatively thin sections of rock. As a result, the ceiling of tomb B1, like those of many others, has collapsed, especially in the eastern part of the tomb near the entrance, leading to considerable damage to the scenes on the east wall and to a lesser extent on the south and north walls. The scenes and inscriptions in the chapel are sculpted in raised relief and painted in bright colours with a bluish-grey background. Below these is a black dado, separated from the scenes by a border comprising three bands of blue, red, and yellow, with thick black lines delineating each.

There is evidence that the B1 chapel was used as a hermit's cell, presumably in the early Coptic era. In addition to a recess in the east wall, a painted cross on the south side of the statue niche, and holes in the ground for storage or to support jars, Blackman also

reported the presence of scraps of mud plaster mixed with chopped straw,[32] which have since been removed.

EAST WALL

North of Entrance (Pl. 74b)

The surviving scenes in the lower section of the east wall depict craftsmen at work. To the left are two kneeling carpenters modelling wooden blocks using chisels and mallets. They are followed by the legs of a standing male, perhaps another workman or a supervisor. The centre of the wall was presumably occupied by two crouching men making/inspecting a necklace on a table or a stand,[33] but only the man to the right is now partly visible. The right side of the bottom register is occupied by three men manufacturing stone vessels of different shapes, two using drills to bore the interior of the jars, while their colleague in the middle appears to be polishing the exterior of another.[34] Addressing the latter, the man to the right says: *jn-jw.k ḥr m33 ntt n ʿḥʿ.n p3 mnḫw m-ntt nn sntr.f* 'do you notice that this splendid one which is without consecration does not keep steady? The man in the centre proposes a solution to the problem saying: *ḥr js ḫt m ḫrt jrt d.j 3 n.k m jmj-r ḫt* '(put) something, indeed, under, as a requirement of use. I will give, indeed, to you, pray, overseer of things'. The man to the left declares: *(jr?).n.j n nḏt-ḥr* ... 'I made (them) for gifts ...'. Two seated men face each other in the second register, but their actions and the remains of the accompanying inscriptions are not clear.

South of Entrance (Pls. 3-6, 75)

The lower and larger section of this wall is reserved for a desert hunt scene. Blackman comments on the artist's naturalistic style and his ability to express life and motion. He compares the lively movements of the fleeing animals and the hounds racing after them or pulling them down in this scene with that in the almost contemporary tomb of Khnumhotep II (no. 3) at Beni Hassan, where 'the animals look as if they are waiting to be shot at'.[35] He also observes that the pose of Khnumhotep II is devoid of animation, while Senbi's posture shows tension and alertness.[36] One of the remarkable achievements of Senbi's artist is that rather than depicting the desert terrain in one,[37] two,[38] or multiple registers,[39] even though undulating,[40] he did away with

[32] Blackman, *Meir* 1, 22.
[33] For examples see Duell, *Mereruka*, pl. 30; Kanawati et al., *Mereruka and His Family* 3:1, pl. 74; Blackman, *Meir* 5, pl. 16; Kanawati and Evans, *Meir* 2, pl. 72.
[34] For similar activities see Duell, *Mereruka*, pl. 30; Kanawati et al., *Mereruka and His Family* 3:1, pl. 74; Blackman, *Meir* 5, pl. 16; Kanawati and Evans, *Meir* 2, pl. 72; Davies, *Deir el-Gebrâwi* 1, pl. 13; Kanawati, *Deir el-Gebrawi* 2, pl. 53.
[35] Blackman, *Meir* 1, 30.
[36] Blackman, *Meir* 1, 30-31.
[37] Newberry, *Beni Hasan* 1, pl. 13; Newberry, *Beni Hasan* 2, pls. 4, 13, 29, 35; Kanawati and Evans, *Beni Hassan* 3, pls. 93-94.
[38] Newberry, *Beni Hasan* 1, pl. 30; Kanawati and Evans, *Beni Hassan* 1, pl. 124; Davies, *Ptahhetep* 1, pl. 21; Harpur and Scremin, *Ptahhotep*, 356, context drawing 5; Davies, *Deir el-Gebrâwi* 1, pl. 11;

registers altogether. This gives the scene a feeling of depth, but, as argued by Schäfer, it still lacks some elements of true perspective.[41] Remaining pigment indicates that the desert surface was originally painted buff-pink, while scattered pebbles were a darker reddish colour, similar to that found in the hunt scenes of Khnumhotep II and Amenemhat (no. 2) at Beni Hassan.[42] Smith mentions that such dots are found in the Old Kingdom only in the tomb of Itet at Meidum.[43] Speckling is also found in the desert scene in the tomb of Djau at Deir el-Gebrawi, yet as these are painted a greenish colour they may instead represent desert vegetation.[44]

Unlike Old Kingdom nobles who simply watched the hunt undertaken by their dependents,[45] Senbi, like his son Wekhhotep I and Khnumhotep II of Beni Hassan,[46] but unlike Djehutihotep of El-Bersha,[47] was actively engaged in shooting, although from outside an enclosure fence,[48] similar to that of king Sahure in his valley temple hunting scene.[49] The tomb owner, identified as *Snbj mꜣꜥ ḫrw* 'Senbi, the justified', leans forward, lifts himself on the toes of his right foot, draws the string of his bow while holding two spare arrows, and aims at the animals inside the enclosure. He wears a kilt that is open in the front to allow freedom of movement, but with an appendage for covering the genitals. A strip of perhaps leather is bound around his torso, with its ends dangling behind him, while a second strip/belt is wrapped round his waist and knotted. Similar tight girdles were perhaps necessary when special effort was exerted; for example, they are used by some of the men who drag the colossus of Djehutihotep of El-Bersha, and also those engaged in protecting the tomb owner.[50] Many men wear similar girdles in fighting activities depicted at Beni Hassan.[51]

Following Senbi is a similarly dressed man, carrying a battle-axe in one hand and holding the top end of some arrows placed in a quiver suspended by a strap from his arm. Hanging from his shoulder is a water skin, obviously needed for the desert trip. The identity of the man is not known, but Blackman suggests that he was perhaps Senbi's son.[52] While this is not impossible, it seems unlikely. It is true that his

Kanawati, *Deir el-Gebrawi* 2, pl. 52; Duell, *Mereruka*, pl. 25; Kanawati et al., *Mereruka and His Family* 3:1, pl. 73; Kanawati, *Teti Cemetery* 8, pl. 47.

[39] For example, Borchardt, *Saꜣḥu-Reꜥ* 2, pl. 17.

[40] Newberry, *El-Bersheh* 1, pl. 7; Kanawati and Abder-Raziq, *Mereruka and His Family* 1, pl. 46.

[41] Schäfer, *Principles of Egyptian Art*, 268-69.

[42] See Kanawati and Evans, *Beni Hassan* 1, pls. 34 a, 35, 37, 38 a-b; Kanawati and Evans, *Beni Hassan* 3, pls. 32, 33, 34 a, 35 b, 36 a.

[43] Smith, *HESPOK*, 268; Harpur, *Maidum*, fig. 80.

[44] Davies, *Deir el-Gebrâwi* 2, 9; Kanawati, *Deir el-Gebrawi* 3, 42.

[45] See for example Davies, *Deir el-Gebrâwi* 1, pl. 11; Kanawati, *Deir el-Gebrawi* 2, pl. 52; Duell, *Mereruka*, pl. 25; Kanawati et al., *Mereruka and His Family* 3:1, pl. 73; Kanawati, *Teti Cemetery* 8, pl.47.

[46] Blackman, *Meir* 2, pl. 8; Kanawati and Evans, *Beni Hassan* 1, pl. 124.

[47] Newberry, *El-Bersheh* 1, pl. 7.

[48] Such enclosure fences are attested in many hunting scenes. See for example Davies, *Antefoker*, pl. 7; Blackman, *Meir* 3, pl. 5.

[49] Borchardt, *Saꜣḥu-Reꜥ* 2, pl. 17.

[50] Newberry, *El-Bersheh* 1, pls. 13, 15, 20, 29.

[51] Newberry, *Beni Hasan* 1, pls. 14, 16; Newberry, *Beni Hasan* 2, pls. 4, 13-16; Kanawati and Evans, *Beni Hassan* 3, pls. 97-98, 101-102.

[52] Blackman, *Meir* 1, 11 n. 4, 31.

representation in similar size to that of the tomb owner is curious and indicates his importance, but perhaps his importance in the context of the desert environment and not vis-à-vis the tomb owner himself.[53] The man's duty was clearly to protect Senbi, hence his holding of the battle-axe in the ready position and the dagger stuck in his belt. Men carrying similar arms often follow noblemen in Middle Kingdom tomb scenes, probably to protect them when in dangerous or simply open places.[54] Such men were usually not members of the nobility and the feather stuck in the hair of Senbi's follower might even indicate his foreign background.

The hunting area is fenced to the left and right, each barrier depicted as a length of diagonal-laced netting supported by equally spaced poles. Inside the enclosure a variety of wild animals can be seen, including dorcas gazelle (*Gazella dorcas*),[55] Nubian ibex (*Capra nubiana*),[56] scimitar oryx (*Oryx dammah*),[57] hartebeests (*Alcelaphus buselaphus*),[58] barbary sheep (*Ammotragus lervia*),[59] African lions (*Panthera leo*),[60] leopards (*P. pardus*), wild bulls/aurochs (*Bos taurus primigenius*),[61] Cape hares (*Lepus capensis*),[62] a desert hedgehog (*Paraechinus* sp.),[63] a striped hyena (*Hyaena hyaena*),[64] and many unleashed hunting dogs (*Canis familiaris*).[65] The latter chase and attack their prey in a number of vignettes scattered across the landscape, creating a dramatic picture of frenetic movement.

At the top left, the tightly curled tail of a *tsm*-hound indicates that a hunting dog has brought down a small, unidentified ungulate, the body of which it now straddles. Below this exchange, two more hunting dogs wearing broad collars run to the right, apparently in pursuit of a herd of hartebeest, which gallops across the terrain. Above these, two dorcas gazelle lie upon the ground. These may be newborn calves, despite their adult-sized horns; as found in Old Kingdom hunting scenes, their elevated position in the picture field possibly indicates that they are some distance from the action.[66] A small Cape hare flees ahead of the ungulates, directly below an unidentified ungulate that appears to be giving birth, the head and foreleg of its emerging calf barely visible beneath the mother's raised tail. Two leopards mate nearby, apparently unaffected by

[53] It should be noted that the similar scene in the neighbouring tomb of Senbi's son, Wekhhotep I, shows the follower's figure much smaller than that of the tomb owner (see below; also Blackman, *Meir* 2, pl. 8).

[54] Newberry, *El-Bersheh* 1, pls. 13, 20, 29; Newberry, *Beni Hasan* 1, pl. 13; Kanawati and Evans, *Beni Hassan* 1, pls. 122 d, 123; Kanawati and Evans, *Beni Hassan* 3, pl. 96.

[55] Osborn and Osbornová, *Mammals*, 175-177; Strandberg, *The Gazelle*, passim; Vernus and Yoyotte, *Bestiare*, 137-141.

[56] Osborn and Osbornová, *Mammals*, 180-185; Vernus and Yoyotte, *Bestiare*, 107-111.

[57] Osborn and Osbornová, *Mammals*, 160-165; Vernus and Yoyotte, *Bestiare*, 170-175.

[58] Osborn and Osbornová, *Mammals*, 171-173; Vernus and Yoyotte, *Bestiare*, 111-114.

[59] Osborn and Osbornová, *Mammals*, 189-192; Vernus and Yoyotte, *Bestiare*, 168-169.

[60] Osborn and Osbornová, *Mammals*, 113-119; Vernus and Yoyotte, *Bestiare*, 152-166.

[61] Brewer et al., *Domestic Plants*, 79-82; Osborn and Osbornová, *Mammals*, 194-196.

[62] Osborn and Osbornová, *Mammals*, 42-45; Vernus and Yoyotte, *Bestiare*, 150-152. See also Stoof, *Hasendarstellungen*, passim.

[63] Osborn and Osbornová, *Mammals*, 19-23; Vernus and Yoyotte, *Bestiare*, 145-146.

[64] Osborn and Osbornová, *Mammals*, 97-105; Vernus and Yoyotte, *Bestiare*, 146-150.

[65] Osborn and Osbornová, *Mammals*, 57-68; Vernus and Yoyotte, *Bestiare*, 544-553.

[66] Evans, *Animal Behaviour*, 57-59.

the chaos that surrounds them. Their behaviour is biologically inaccurate, however, as in all cat species the female usually crouches upon the ground during copulation.[67] Directly in front of the pair, a dorcas gazelle nibbles a small shrub calmly as she suckles her calf. At top right, on a hillock above the latter, a fallen ungulate lies upon its back with its hind legs extended and its forelegs bent, its attacker no longer extant, while below this pair a large bull, as revealed by its long tail and prominent testicles, faces right with its forelegs locked.

Senbi's hunting dogs attack their prey relentlessly in the lower half of the enclosure. On the left, a hound leaps up to sink its teeth into the nape of a wounded Nubian ibex, which braces its legs and leans back to collapse upon the substrate as it attempts to pull itself free. Its long and prominent tongue indicates that it is vocalising in pain or fear.[68] Below this pair, a second dog runs beside a fleeing dorcas gazelle and bites it upon the neck, once again causing its prey to vocalise. Before them gallop a pair of ibex and a herd of scimitar oryx accompanied by a calf, trying, unsuccessfully, to avoid the tomb owner's arrows; however, the calf's attention is distracted by an aggressive encounter between a male lion and a wild bull. The lion is attempting to suffocate the bull by biting its muzzle. This behaviour, which is typical of lions when attacking large prey,[69] is found in a number of desert hunt scenes in the Old Kingdom.[70] Senbi's artist is particularly successful in portraying the action, showing the lion with an erect tail, indicating its excitement, while the bull has its tail between its legs, implying fear or pain. Unlike Old Kingdom examples, where the bull usually stands motionless and the lion often sits upon the substrate, here both animals pull back fiercely - the bull to release its muzzle from the lion's jaws and the lion to drag its victim to the ground, or perhaps to avoid a kick from its suffering prey.

At the lower left corner of the enclosure, a hunting dog advances to the right along with a lumbering hedgehog and a nimble Cape hare, the latter giving a flying leap in its haste. The three animals face yet another hound that has managed to pull down an ibex. An arrow has already wounded the ibex, but the dog also attacks its throat, ensuring its death as its lolling tongue reveals. Further to the right, however, two more dogs have yet to dispatch their prey: one rears up to bite the nape of a barbary sheep, which collapses to the ground vocalising loudly, while the other has grasped the muzzle of a hartebeest, wrenching its head back as the animal's legs fold beneath it. Two more hartebeest, one of which is wounded, leap to the right. Finally, between the busy hunting dogs stands a single striped hyena that is pierced in both a leg and its mouth by the tomb owner's arrows. The animal stands on its hind legs to paw at the arrow's fletching as though trying to extract it. This identical motif first occurs in king Sahure's

[67] Estes, *Behaviour Guide*, 356. See also Ikram, *GM* 124 (1991), 59, fig. 15.
[68] See Evans, *Animal Behavior*, 193-194.
[69] Evans, *Animal Behaviour*, 112.
[70] See for example Davies, *Ptahhetep* 1, pl. 21; Harpur and Scremin, *Ptahhotep*, 356, context drawing 5; Duell, *Mereruka*, pl. 25; Kanawati and Abder-Raziq *Mereruka and His Family* 1, pl. 46; Kanawati et al., *Mereruka and His Family* 3:1, pl. 73.

valley temple hunting scene,[71] and indeed the general composition of Senbi's hunting scene bears many similarities to the latter.

The upper part of the wall preserves the remains of an offering table scene. To the right are feet, presumably those of the seated tomb owner, and part of the leg of his chair. Placed before him is an offering table laden with bread and other food items, including the foreleg of an ungulate, with a smaller table positioned beneath it. On the opposite side of the table is a tall beverage jar(?) and parts of two offering bearers. The first is perhaps carrying the foreleg of an animal, while the second carries a brace of fowl and has already wrung the neck of a goose (Anatidae sp.), which now lies dead at his feet.

SOUTH WALL (Pls. 7a, 8-20, 76-77)

The space on this wall is divided horizontally into two sections of equal height, both of which are reserved for the related themes of viewing herds, slaughtering animals, and the presentation of food offerings. To the extreme right of the top section, the tomb owner is seated upon an ebony chair with a low, cushioned back and lions' legs. He wears a shoulder-length wig, a collar, bracelets, and a short kilt, and holds a folded cloth in his left hand while extending his right towards an offering table laden with twelve half-loaves of bread/reed leaves. Above and on the opposite side of the table are a variety of offerings depicted with particularly beautiful and colourful details. Among these are cuts of meat including the forelegs, ribs, and heads of different animals, fowl, vegetables (such as lettuce and onions), and fruits (such as figs and grapes), as well as baskets and jars containing beverages, and other food items. A line of text above the tomb owner's figure identifies him as: *jrj-pꜥt ḥȝtj-ꜥ jmj-r ḥmw-nṯr Snb.j mȝꜥ-ḥrw* 'the hereditary prince, the count, the overseer of priests, Senbi, the justified'. Beneath the table an inscription begins on the left side and continues on the right: *dbḥt ḥtpt ḫȝ kȝ ḫȝ ȝpd ḫȝ ḫt nbt nfrt wꜥbt n kȝ n jmȝḫjj ḥȝtj-ꜥ Snb.j mȝꜥ-ḥrw* 'requirement of offerings, one thousand of oxen, one thousand of fowl, one thousand of every beautiful and pure thing for the ka of the honoured one, the count, Senbi, the justified'.

The upper part of the wall to the left of the stack of food and drink was originally occupied by an offering list that is now almost entirely destroyed, except for part of one item: [*mw sȝ*]*ṯ* 'water for pouring' (one), and a few numbers referring to the required quantities of now damaged items. The register beneath the list depicts, from right, a man carrying the foreleg of an ox and another piece of meat, while nearby two butchers are dismembering an animal whose throat has been slit and now flows with blood. One butcher addresses his companion saying *ḫȝḫ s[n]* 'speed them up'. Another butchery scene follows, but this is largely damaged. Further to the left are two men, one of whom holds c. seven ducks (Anas sp.)[72] by the wings in his left hand while also pinning a common crane (Grus grus)[73] under his right arm and grasping its beak. His colleague in

71 See Ikram, *MDAIK* 57 (2001), 130, fig. 4. The motif is otherwise rarely attested. For other examples, see ibid., 198, Table 3.
72 For the representation of duck species, as well as geese and swans, see Houlihan, *Birds, passim*.
73 Houlihan, *Birds*, 83-86.

the meantime appears to have wrung the neck of another duck that now lies dead at his feet. Above the men is written: ...*n kȝw.f* ...[*pr-*]*dt nʿ*...for his kas, ... the funerary estate of'. A female bearer holding a pintail duck (*A. acuta*)[74] in her right hand walks nearby followed by priests performing an offering ceremony. The first is pouring water with the label: *wt(j) sȝt* 'the embalmer making libation', while the second throws incense in a censer and is described as: *smr ḥr sntr* 'the companion censing'. Three kneeling men can then be seen, each of whom wears a shoulder-length wig and sash, and holds one fist to their chest and the other raised high. The latter are probably lector priests supervised by an official who holds a staff and wears both a sash and a long, projecting kilt.

The remaining part of the register depicts the presentation of animals to Senbi. An emaciated herdsman, with visible collarbones and ribs, bushy hair, and a tufted beard, heads the procession. Blackman suggests that he belongs to the Beja tribes,[75] nomads who have inhabited the eastern desert of Egypt and Sudan from the pharaonic period until the present day; as renowned pastoralists, their services were presumably needed following the First Intermediate Period as the country was building up its resources. Leaning on an undulating staff, probably a tree branch, the herdsman leads on a rope a fat ox labelled: *rn n jwȝ n kȝ...* 'prime[76] ox, for the ka ...'. Another herdsman then encourages three animals, perhaps gazelles, to move forward, followed by a worker who urges a Nubian ibex[77] to proceed, and then a third possibly clasping an oryx by the horns.[78] Next, a herdsman carries a tall vessel with his left hand, while with the right he presumably grasps the forelegs of a calf that is slung upon his back.[79] A cow follows closely, peering up at her young anxiously as the rest of the herd trails behind her. The first member of this group bends down to nibble at a shrub, another animal appears to have a deformed horn, while at the rear a tiny calf wanders in the opposite direction. The latter faces a hornless animal that has lain upon the ground, causing a herdsman carrying a vessel in his right hand to use his stick to urge it to move. A second herd of short-horned cattle, some with deformed horns, gather behind him. One of these turns back and vocalises as it stares at a herd member that has stopped to scratch its head with its right hind leg. This rarely depicted action is attested in the Old Kingdom period in three instances at Saqqara,[80] and it also occurs in the Sixth Dynasty tomb of Pepyankh the Middle (D2) at Meir.[81] Unlike the earlier examples, however, where the animal rubs its neck or muzzle, in the present example it scratches the top of its head in a rather violent manner. In response to this behaviour, a herdsman at the rear brandishes his stick and utters words that are partly damaged: *n rš* ... '... do not enjoy...'.

[74] Houlihan, *Birds*, 71-73
[75] Blackman, *Meir* 1, 29, 32.
[76] For the translation of *rn* as 'prime' see Swinton, *Management of Estates*, 35.
[77] When the scene was recorded by Blackman (*Meir* 1, pl. 10), the horn of the animal was better preserved.
[78] This may be suggested by the animal's tail and the position of the herdsman's arms (see also Blackman, *Meir* 1, pl. 10).
[79] For calves carried in this manner by herdsmen see Evans, *Animal Behaviour*, 71, and for examples see Lepsius, *Denkmäler* II, 31 a; Wild, *Ti* 2, pl. 114; Blackman, *Meir* 2, pl. 7.
[80] Evans, *Animal Behaviour*, 76-77.
[81] Blackman, *Meir* 4, pl. 14; Kanawati, *Meir* 1, pl. 84.

At the extreme right of the lower section of the wall scene the tomb owner stands wearing a shoulder-length wig, a collar, bracelets, and, curiously, a type of tunic usually chosen for sporting activities and similar to those worn while spearfishing and fowling (see below). Holding a staff with his right hand and a folded cloth in his left, he is accompanied by his wife, identified as: *jmȝḫjjt pr ḥmwt Mr.s* 'the honoured one of the house of women/ wives, Meres'. The latter wears a collar and a long dress with shoulder straps, and holds a lotus flower in her right hand while clutching her husband's leg with her left. Behind the pair stands a servant wearing a long dress and balancing a set of vessels upon her head. A line of text written above the group reads: *ḥtp dj nswt ḫȝ t ḥnḳt kȝ ȝpd n jmȝḫjj ḥȝtj-ᶜ Wḫw-ḥtp(.w) sȝ Snbj nb jmȝḫ* 'an offering which the king gives, one thousand of bread, beer, oxen, and fowl for the count Senbi, son of Wekhhotep, possessor of veneration'. In front of the group the scene is described as: *mȝȝ jwȝw sḏȝw* 'viewing the precious oxen'.[82]

The cattle and related activities viewed by Senbi are placed in two registers. Heading the procession in the top register, as in the upper section of the wall, is a herdsman with Beja-like characteristics who leads two large bulls. Using a short stick for support, he is unusually thin, with bushy hair, hunched shoulders, and distorted legs.[83] A man with very similar features is represented in the neighbouring tomb of Senbi's son, Wekhhotep (B2),[84] also ahead of other herdsmen. Another herdsman follows the emaciated man, holding a stick and encouraging two more oxen to move; one of these is hornless, while the second has a deformed horn. Above the animals is written: *rdjt mȝᶜw mḏwt nt ḫr-jb n kȝ n jmȝḫjj ḫr Wsjr ḥȝtj-ᶜ Snbj nb jmȝḫ* 'presenting the produce of the favourite byres to the ka of the honoured one before Osiris, the count, Senbi, the possessor of veneration'.

Next in the procession comes a herd of cows (as revealed by their small udders), some with long horns and others hornless. The last cow is delayed while it scratches its muzzle, but the herdsman who follows appears to be urging it and the other animals to move by raising his stick. The first cow, which is accompanied by its calf, is described as: *[ḳ]n ḥs nb* 'the strong one which the lord favours'. Above the rest of the cows is written: … *ḥwjjw jnjj m niwwt.f nt Šmᶜt* '[conducting?] the cattle which are brought from his towns of the South'. A kneeling herdsman can then be seen exerting great effort to deliver a spotted cow. The mother's tongue protrudes prominently, indicating that she is vocalising loudly with the pain as her calf's head, forelegs, and the amniotic membranes emerge with the help of her human assistant.[85] An overseer, leaning on his staff and wearing a striped and flaring kilt with a sash over his shoulder, points to the labouring worker saying: *mnjw sf bn* 'Herdsman, be gentle of/in handling'. It is interesting to note that the composition of this vignette is identical to a calving scene in

[82] Blackman translates *sdȝw* as 'young cattle' (*Meir* 1, 33).

[83] Chassinat (*BIFAO* 10 (1910), 169-173) identified this and other cases as *genu recurvatum*, a condition that can be caused by a kick to the knee-joint. Herdsmen with a similar deformity are attested in a number of Old Kingdom tombs. See for example Davies, *Ptahhetep* 1, pls. 21, 28; Harpur and Scremin, *Ptahhotep*, 357, context drawing 6; Kanawati and Abder-Raziq, *Unis Cemetery* 2, pl. 71.

[84] Blackman, *Meir* 2, pl. 3.

[85] For a discussion of cattle birth scenes, see Evans, *Animal Behaviour*, 169-172.

the Fifth Dynasty tomb of Ti at Saqqara, which, unusually, also shows the delivery of the birth membranes.[86] Despite the noise, an elderly herdsman with receding hair sits before the cow, sleeping soundly on his folded mat.

The remainder of the register is occupied by the representation of two pairs of fighting bulls.[87] Two men stand between the first pair and each brandishes a stick towards the aggressive animals, one of which runs to the left, while the other adopts an unusual stance with both sets of legs inclined inward. The men's action is described above them as: *wpt k3w* 'separating the bulls'. Above the bull to the right is written: *k3 nḫt mjtj Ḥpw 2 ḫnm.n Ḥs3t* 'a strong bull, like two Apis-bulls, whom Hesat has nourished'. The meaning of the phrase above the second bull is not clear: *msḏ ḥr t3t* 'the rival and youthful(?)'. The second pair of bulls has already started to fight, with their horns piercing each other's neck. A herdsman hastens to separate them using his stick. The inscription above him reads: *sfḫ k3 nḫt sḏm.f sfḫ m smn snt*[88] *n.f mnjww m ḥr.f* 'separating the strong bull. It obeys the separating when the herdsmen withstand it firmly on the face'. The translation of the text written above the bull to the right is only tentative: *nb sprw m ḫnjjw(t nn) sntj* 'master of making a miss with the missiles (lit. spears), without a likeness'. Behind the herdsman, perhaps avoiding the fray, is a long-tailed and collared dog named: *Ṯ3w n ʿnḫ n Snbj* 'Breath-of-life-of-Senbi'.

Seven men are depicted in the bottom register approaching Senbi and his wife while carrying cuts of meat and poultry. The first man holds what appears to be the haunch of a large ungulate, yet the accompanying inscription says: *ḫpš n k3 n Snbj m3ʿ ḫrw* 'a foreleg(?) for the ka of Senbi the justified'. The second man brings cuts of meat on two trays supported on his shoulders. The accompanying text reads: *jms n k3 n jm3ḫjj ḥ3tj-ʿ Snbj* 'presenting to the ka of the honoured one, the count, Senbi'. The third man carries the haunch of a smaller animal, which is wrapped across his shoulders. The accompanying caption reads: *jms n k3 n Snbj m3ʿ ḫrw* 'presenting to the ka of Senbi the justified'. The fourth man is wringing the neck of a pintail duck, while three others of the same species already lie dead upon the ground. His action is described as: *jnw sḫpt n k3 n Snbj m3ʿ ḫrw* 'tribute which is brought for the ka of Senbi the justified'. The fifth man carries various cuts of meat in his left arm as well as the head of a calf on his right shoulder, with a caption similar to that of the third man. The sixth man carries the haunch of a small ungulate over his shoulder while supporting the head of a calf in his raised right hand, with the accompanying label: *jms n k3 n ḥ3tj-ʿ Snbj m3ʿ ḫrw* 'presenting to the ka of the count, Senbi the justified'. The last man carries in each hand one side of the complete ribcage of a large animal. His caption is identical to those of the third and fifth men.

[86] See Evans, *Animal Behaviour*, 170 n. 3, fig. 11-3; Wild, *Ti* 2, pl. 124.
[87] For examples of bull fighting see De Morgan, *Catalogue des monuments* 1, 160-61; Davies, *Deir el-Gebrâwi* 1, pl. 11; Davies, *Deir el-Gebrâwi* 2, pl. 9; Kanawati, *Deir el-Gebrawi* 2, pl. 52; vol. 3, pl. 61; Blackman, *Meir* 5, pl. 32; Kanawati and Evans, *Meir* 2, pl. 92; Kanawati, *El-Hawawish* 1, fig. 10; Kanawati, *El-Hawawish* 2, fig. 20. For different interpretations of the significance of bull fighting see Kanawati, *BACE* 2 (1991), 51-58; Galán, *JEA* 80 (1994), 81-96. It is curious that all known examples of bull fighting are found in tombs of Upper Egyptian nobles, with no attested examples in the Memphite cemeteries (Montet, *Vie privée*, 97; Vandier, *Manuel* 5, 58).
[88] Faulkner, *Dictionary*, 234.

Nearby, two men are binding an ox in preparation for its slaughter. The animal voices its protest as one of the butchers grasps its horns and presses down on its head with his foot and the other ties three of its legs together, in anticipation of severing its free foreleg. The man holding the rope is presumably calling on the butcher standing behind him: *mj jrjj.k bw nfr* 'come, that you may do good things'. Four butchers then dismember an animal. The two to the right are working on a foreleg. One man orders his companion: *jr* … 'make …', to which he responds: *twt nfr hrw* 'fair; the day is beautiful'. The other two men are working on the hind leg. Holding the knife, the butcher tells his assistant to tug the leg: *dwn n.k ḥsjj* 'pull towards you, O praised one'. A man carrying a bowl, presumably to collect blood, approaches two butchers slaughtering an ox. One of the men has bound the animal's four legs and holds the rope tight to prevent it from resisting, while the second has already cut its throat with the blood pouring forth; indeed, the animal's tongue lolls upon the substrate, suggesting that it is close to death. Addressing his companion, the latter says: *pr ꜥ.k dj.n mꜢꜥ stpt n kꜢ n jmꜢḫjj ḥꜢtj-ꜥ Snbj mꜢꜥ ḫrw* 'let your arm forth, that we may give offerings of the choice things to the ka of the honoured one, the count, Senbi, the justified'. His companion repeats: *mꜢꜥ n Snbj mꜢꜥ ḫrw* 'offerings to Senbi, the justified'. Two men handle the last animal, which is bound, struggling, and vocalising loudly. One of the butchers holds its horns firmly and shouts to his companion: *dj n.k sw ḥr gs.f* 'place it on its side', to which the latter responds: *mꜢꜥ n Snbj mꜢꜥ ḫrw* 'offerings to Senbi, the justified'.

The slaughtering is supervised by an older man with a bulging stomach and rolls of fat on his chest. Wearing a long kilt and holding a stick/whip in both hands, he is described as: *jmj-r ꜥḫnwtj Nṯrw-ḥtp(.w)* 'the chamberlain, Netjeruhotep'.[89] Addressing the butchers, he says: *jrjw ḥsjj n Snbj mꜢꜥ ḫrw …n prj …* 'do what is praised for Senbi the justified… us bring forth…'. To the extreme left of the register is a dramatic scene in which an ox is roped in readiness for slaughter. The animal is struggling and obviously angry, calling out and snorting a large volume of fluid from its nostrils.[90] One man pulls vigorously on a rope that is tied to the ox's foreleg, attempting to unbalance it, while the individual who faces the animal holds a short rope with one hand and wields a stick defensively in the other. Addressing his companion he shouts: *mꜢꜥ n Snbj mꜢꜥ ḫrw* 'offerings to Senbi, the justified'. The latter responds: *nḏr* 'hold fast', and, perhaps in response to animal's aggression, also *ḥs ḥs ṯw* 'turn away, turn away'.

NORTH WALL (Pls. 7b, 21-32, 79-80)

The decorated surface of the north wall is divided horizontally into two sections of equal height, the upper of which is devoted to the tomb owner receiving gifts and viewing activities and equipment relating to sport and security, while the lower section is reserved for marshland activities and agricultural pursuits. On the left in the upper

89 See Blackman, *Meir* 1, 34, pl. 11.
90 Although the paint is now missing, a watercolour of the scene published by Blackman (*Meir* 1, pl. 30) indicates that the fluid was originally red, suggesting that it represents blood. Bleeding from the nostrils is not common in cattle and is usually a sign of disease. Its occurrence here may thus be primarily for dramatic effect, to emphasise the bull's exertion and distress.

section is a figure of the tomb owner wearing a shoulder-length wig, a collar, bracelets, and a short, projecting pleated kilt. He holds a staff in his left hand and a sceptre in his right, and is identified as: *jrj-pꜥt ḥꜣtj-ꜥ Snb.j mꜣꜥ ḫrw* 'the hereditary prince, the count, Senbi, the justified'. Behind him stand two men in superposed registers. The man in the top register carries a staff and sandals for Senbi and is described as: *jrj mrḥt* 'keeper of salve', while the one in the lower register is designated as: *jmj-r rḫtjw* 'overseer of washermen' and carries an instrument over his shoulder presumably for beating wet cloth. Both men wear long kilts.

The space in front of the tomb owner is divided into two registers, which will be described separately although the activities shown above one another in the two registers are sometimes related. Heading the top register is a mature-aged man with an enlarged breast wearing a long kilt. Described as: *jmj-r pr Ḫnmw* 'the overseer of the house, Khnum', he presents Senbi with an ornamental collar, the inscription before him describing his action as: *ḥꜣt ḏbꜣwtt wsḫ n kꜣw.k* 'the best of adornment, a *wsḫ*-collar for your kas'. He is followed by three females wearing long wigs and long, tight dresses with shoulder straps, and carrying sistrums and menat-necklaces used in the cult of Hathor, who extend their hands towards Senbi. The text written in front of the first woman reads: *n kꜣw.k mnjwt nt Ḥwt-ḥr nbt Ḳjs* 'to your kas, the menats of Hathor, lady of Qusiya'. The text before the second woman is partly missing: *n kꜣw[.k …] ḥs.s ṯw* 'to your kas, …, that she may favour you'. Before the third woman is written: *n kꜣw[.k] mnjwt nt mwt.k Ḥwt-ḥr swꜣḥ.s ṯw r rnpwt mrr.k* 'to your kas, the menats of your mother Hathor, that she may make you endure for the years you desire'.

Behind the women are two collars and four bracelets placed on two low tables, followed by four men wearing long kilts and bringing objects to Senbi. The first man clasps a perfume jar in both hands labelled *stj-ḥb* '*stj-ḥb* oil', while the second carries a sistrum in one hand and a menat-necklace in the other. He says: *n kꜣw.k mnjt nt Ḥwt-ḥr ḥs.s ṯw* 'to your kas, the menat of Hathor, that she may favour you'. Next comes a man carrying a toilet-box and a sack containing a mirror, as the label *ꜥnḫ* indicates. The last man is the supervisor. Urging the one in front of him to move, he says: *nm ṯ(w) nfr hrw mꜣꜣ n.f bw nfr* 'proceed! It is a beautiful day! See, good things for him'. The remaining part of the top register contains various objects arranged according to their types. Thus, placed on a stand and a table are metal objects such as jars, a censer, and a mirror. Weapons, such as shields, bows and arrows, and battle-axes follow these. Next come objects for personal use, such as a bed, chests, a table, perfume jars, stone vessels, a fan, a mirror, a flywhisk, sandals, and an adze. The rest of the register is missing.

The first man in the second register is playing a harp, with its sound box decorated with a *wḏꜣt*-eye motif. Written before him are probably the lyrics of the song he sings: *kꜣ Ḥwt-ḥr nt mrwt Jḥwjjw Jḥwjjw jw.s kꜣt m wšr Jḥwjjw m wšr Snbj Jḥwjjw* 'exalted is Hathor of Love[91], O Ihuyu,[92] O Ihuyu, she is exalted on the holiday,[93] O Ihuyu, on the

[91] Indicating that Hathor as a goddess of love.

[92] According to Blackman (*Meir* 1, 23-24), the Ihuyu are men with castanets and menats, namely the two shown in this register.

[93] Blackman (*Meir* 1, 23 n. 6) proposes that *wšr* followed by the sign N5 could mean 'an empty day', 'a day in which no work is done', i.e. a holiday.

holiday, O Senbi, Ihuyu'. Behind the harp player are three standing men, all wearing long kilts. The first of these carries four loaves of bread of two different types as well as objects dangling from his hands, suggested by Blackman to be tongs with which he has removed the bread from the oven.[94] The text before him reads: *n k3.k (s)nw*[95] *n Ḥwt-ḥr ḥs.s ṯw* 'to your ka, the *snw*-offering of Hathor, that she may favour you'. The following two men wear menats and hold castanets. The first of the two says: *nbw m sšw nbw m sšw swt swt k3.s ḥtp.t* 'the golden one is in the marshes, the golden one is in the marshes, the places, the places of her ka, may you[96] be content'. The second man repeats: *ḥtp.t nbw* 'may you be content, O golden one'.

Nearby, three men are squatting while singing and clapping for rhythm, with the lyrics of their song written above them. The man to the left says: *mnw k3w ꜥ3 m pr pn nb.j jb(.j) r w3ḥ.k* 'may the kas endure here in this house, O my lord, my wish is that you live long'. His two companions to the right respond: *mr(.j) w3ḥ.k nb(.j) mr(.j) w3ḥ.k jr.k sw m rnpt ḫ3 nb(.j) mr(.j) w3ḥ.k snb.tj ꜥnḫ.tj r nḥḥ* 'I wish that you live long, my lord, I wish that you live long. May you make it to a thousand years, my lord, I wish that you live long, may you be healthy and may you live for ever'. Three male dancers follow the three singers, each of whom strikes a different pose while clicking his fingers. The first from left says: *jrjj.k ḥsjj j...j...r nḥḥ* 'may you make, O praised one, ... forever'. The one in the middle says: *ꜥnḫ.k n(.j) mk hrw nfr nb(.j) mrjj(.j) w3ḥ.k* 'may you live for me; behold the beautiful day; O my lord, my beloved, may you live long'. The man to the right shouts: *jḫ wḥm.k ḥḥ ḥb-sd*[97] *[ḥ]nm rf ṯw Ḥwt-ḥr jm* 'O, may you repeat a million jubilees, smelling you Hathor therein'. Curiously, a naked boy carrying a battle-axe follows the group. Both he and the dancers wear bracelets on their right wrists and, in addition, the child has a tuft of hair on the top of his head. Above him is written: *Snbj w3ḥ[.k] r n[ḥḥ]* 'Senbi, may you live for ever'.

Three pairs of wrestlers are depicted next; in each case one man is painted in a noticeably darker colour than that of his counterpart, which allows the movements of their intertwined bodies to be distinguished. A similar technique was used in wrestling scenes at Beni Hassan, but perhaps due to the large number of wrestlers painted there, the colouring is inconsistent, and the figures are not as well-proportioned or the holds and movements as successful as those in the tomb of Senbi.[98] The dialogue between each couple is written above them. Thus the man to the right in the first pair (from left) has a firm hold of his companion's head and says: *jn(.j) n.k sj mk sḫr(.j) ṯw ḥr.s* 'I will remove it (the head) for you; behold, I will make you fall over it'. His companion reaches for both of his adversary's legs and shouts: *w3ḥ jb.k dj(.j) m33.k ṯw ḥr st-r.k* 'as your heart lives,[99] I will make you realise that you are not up to your words'.[100] One of the wrestlers in the central pair has fallen on the ground with the other man pressing him down. The words of the fallen one are badly damaged, while for the man on top we

94 Blackman, *Meir* 1, 23.
95 For this writing see Blackman, *Meir* 4, pl. 15.
96 The second person feminine is used, presumably referring to Hathor.
97 See Blackman, *Meir* 1, 26 n. 2.
98 See for example Kanawati and Woods, *Beni Hassan*, photographs 76-83; personal examination.
99 A similar expression is used as an oath in modern Egyptian colloquial Arabic.
100 In other words, that you will not be able to achieve what you have just said.

read: *…k r-gs rmṯ* '…you … in the presence of people'. One member of the right-hand team is using his body-weight to push his opponent down. The latter refuses to admit defeat and says: *mj ḫsj ꜣ ksm.n(.j) wj mk tw jwt* 'come, feeble one! indeed I have turned myself round; behold, it is you who is yielding'. The one on top responds: *m [ꜥ]bꜥ mk n ꜥꜣ mꜣꜣ tw* 'look! the boasting; behold! we are here, see for yourself'.

Three priests wearing long kilts follow, the first of whom is too damaged to study his identity or action.[101] The second priest holds a staff and is described as: *ẖrj-ḥbt* 'lector priest'. He is said to be *šdt sꜣḫw* 'reciting glorifications'. The third priest wears a leopard skin, a small part of which is preserved. Identified as *sm ꜥnḫ.j* 'the sm-priest'Ankhi', he throws some incense into his censer, with the text before him describing his action as: *jr sḏt snṯr* 'burning incense'. The priests were probably followed originally by eight bearers supporting a bier on their shoulders that carried the wooden coffin of Senbi, but only the four men in the front are preserved. The scene is labelled: *ḳrs r ẖrt-nṯr* 'burial at the necropolis'. The rest of the register is missing.

The lower section of the wall is occupied by activities in the marshlands and in the fields. To the extreme left is a composite fishing and fowling scene.[102] In the centre is a beautifully represented papyrus thicket, with both open and closed umbels indicated. Unlike similar scenes from the Old and Middle Kingdom periods where the papyrus flowers are depicted in parallel rows, usually only in the upper part of the scene,[103] Senbi's artist has freed himself from the principle of parallel rows to distribute the umbels throughout the entire thicket, giving it a feeling of depth, if not true perspective.[104] Indeed, like his rendering of the desert terrain, his depiction of the thicket is very innovative. In the waters below the vegetation is a highly realistic image of a herd of hippopotamus (*Hippopotamus amphibius*),[105] their rotund bodies overlapping and resting upon one another, as two of them threaten Senbi's approaching canoe with open mouth displays.[106] The animals are represented with three toes on each foot; in reality, however, hippos possess four digits. The rare image of a hippo calf lying upon its mother's back possibly reflects the artist's direct observation of this common behaviour in the wild, but it is interesting to note that a young hippopotamus also clambers onto an adult in the Old Kingdom tomb of Ti at Saqqara.[107]

[101] Blackman's suggestion that he held a brush and could be removing the footprints (*Meir* 1, 27 n. 4) is unlikely, as such a person is usually the last in the row of priests. It seems more likely that he is another lector priest, perhaps holding an unrolled papyrus scroll.

[102] Examples from the Old Kingdom have been collected by Harpur (*Decoration*, 355ff., feature 3). See also Kanawati et al., *Teti Cemetery* 3, pl. 76; Kanawati and Abder-Raziq, *Unis Cemetery* 2, pl. 37.

[103] For Old Kingdom examples see Blackman, *Meir* 4, pls. 7, 17; Kanawati, *Meir* 1, pls. 80-81; Blackman, *Meir* 5, pls. 24, 28; Kanawati and Evans, *Meir* 2, pls. 84, 88; Davies, *Deir el-Gebrâwi* 1, pl. 5; Kanawati, *Deir el-Gebrawi* 2, pl. 47; Davies, *Deir el-Gebrâwi* 2, pl. 3; Kanawati, *Deir el-Gebrawi* 3, pl. 58; Kanawati and Abder-Raziq, *Unis Cemetery* 2, pl. 37; Kanawati et al., *Teti Cemetery* 3, pl. 76; vol. 5, pls. 53-54. For Middle Kingdom examples see Blackman, *Meir* 3, pl. 6; vol. 6, pl. 13; Newberry, *Beni Hasan* 1, pls. 32, 34; Kanawati and Evans, *Beni Hassan* 1, pls. 132, 136.

[104] Agreeing with Schäfer, *Principles of Egyptian Art*, 268-269.

[105] Osborn and Osbornová, *Mammals*, 144-148; Vernus and Yoyotte, *Bestiare*, 248-263.

[106] For this aggressive display, see Evans, *Animal Behaviour*, 135-137.

[107] See Wild, *Ti* 2, pl. 119.

Within the dense vegetation above the herd lurk a number of different animals; the difficulty in discerning these against the busy background adds to the realistic impression of the thicket. To the left, a grey heron (*Ardea cinerea*)[108] can be seen resting upon a curving stalk, while on the far right, a hoopoe (*Upupa epops*),[109] with its distinctive crest and long sharp beak, has alighted on an umbel. In contrast to the calm demeanor of these birds, in the upper-right quadrant of the thicket a duck or goose swoops down frantically to chase a common genet (*Genetta genetta*)[110] away from her brood. While one chick remains safely in the nest, the predator has managed to grasp its sibling, holding the little bird's head in its jaws as it looks over its shoulder. Insects also inhabit the thicket, with a dragonfly (Order Odonata)[111] visible in the centre of the vegetation and two butterflies (possibly African monarch butterflies, *Danaus chrysippus*)[112] represented on the left and right, towards the top. Three birds rest on the umbels that peep above the thicket: a sacred ibis (*Threskiornis aethiopicus*)[113] sits upon a large nest, protecting two small eggs; a tiny common kingfisher (*Alcedo atthis*)[114] also adopts a nesting pose with wings stretched forward, although the nest-cup itself is not apparent; and finally, a pied kingfisher(?) (*Ceryle rudis*)[115] perches on a flower. The latter faces a larger and more detailed depiction of a pied kingfisher in mid-flight. Fully inverted, the bird displays the characteristic hover-and-dive hunting behaviour of this species and a popular motif during the Old Kingdom period.[116] To the left and right of the hunting kingfisher, eight birds flush upward, including Egyptian geese (*Alopochen aegyptiaca*),[117] a sacred ibis, and pintail ducks.

The marsh scene follows the usual orientation in which spearfishing is depicted to the left and fowling with the throw-stick to the right.[118] During both activities, the tomb owner wears a skullcap that covers his ears, but without a fillet and streamer, as was common during the Old Kingdom period and remaining popular during the Middle Kingdom.[119] Senbi is the only surviving example without the fillet and streamer at

[108] Houlihan, *Birds*, 13-16.

[109] Houlihan, *Birds*, 118-120.

[110] Osborn and Osbornová, *Mammals*, 88-92; Vernus and Yoyotte, *Bestiare*, 610. Blackman (*Meir* 1, 28) identifies the animal as a red fox (*Vulpes vulpes*), while Osborn and Osbornová (*Mammals*, 73-74) believe that it may represent a Rüppell's fox (*Vulpes rueppellii*). It should be noted, however, that common genets are traditionally depicted in marsh scenes.

[111] For a discussion of dragonflies and other possible species represented in Old Kingdom art, see Evans, *Animal Behaviour*, 52-53.

[112] Vazari and Evans, *J. Lepid. Soc.* 69.4 (2015), 242-267.

[113] Houlihan, *Birds*, 28-30.

[114] Houlihan, *Birds*, 113-114.

[115] Houlihan, *Birds*, 114-116. The bird appears to display the pied kingfisher's crest, but its tail is slightly too short.

[116] Evans, *Animal Behaviour*, 125-126.

[117] Houlihan, *Birds*, 62-65.

[118] Facing the opposite direction is found in many examples in both Memphite and provincial cemeteries, however. For Old Kingdom examples see Moussa and Altenmüller, *Nianchchnum*, pl. 74; Altenmüller, *Mehu*, pl. 13; Petrie, *Dendereh*, pl. 5; Edel, *Qubbet el-Hawa* 1, pls. 14, 21. For Middle Kingdom example see Newberry, *Beni Hasan* 1, pls. 32, 34; Kanawati and Evans, *Beni Hassan* 1, pls. 132, 136.

[119] For this headdress in the Middle Kingdom see for instance Newberry, *Beni Hasan* 2, pls. 29, 35; Newberry, *El-Bersheh* 1, pls. 8-9

Meir,[120] but Middle Kingdom parallels are found at Beni Hassan.[121] Senbi also wears a collar and a sports tunic. He is shown aboard a papyrus boat without a wooden deck, which is repeated in his son Wekhhotep I's tomb (B2),[122] but is unattested in later tombs at Meir.[123] Using a particularly long spear, he has caught the traditional two fish, a tilapia (*Tilapia* sp.)[124] and a Nile perch (*Lates niloticus*)[125]. The representation of small clumps of water plants beneath the boat, rather than filling the submerged area as well as the 'mound of water' with different species of fish, makes the scene more realistic and credible. Two horizontal lines of hieroglyphs identify the tomb owner and describe his actions: *stjt mḥjt jn jm3ḫjj ḫr Wsjr nb smjt jmntjt ḥ3tj-ʿ jmj-r ḥmw-nṯr Snb.j m3ʿ-ḫrw* 'spearing fish by the honoured one before Osiris, lord of the western desert, the count, the overseer of priests, Senbi, the justified'. Facing him, but in diminished size, is his wife, holding a bunch of papyrus stalks. The upper part of her figure is now missing and so is part of the inscription identifying her: … *Mr.s nbt jm3ḫ* ' … Meres, the possessor of veneration'.

On the opposite side of the thicket is the tomb owner facing left and similarly dressed. He stands aboard a similar papyrus boat and holds a throw-stick in his raised hand while grasping three fledglings in the other. The text above him describes the action as: *ʿm3 r rw jn ḥ3tj-ʿ ḫtmtj-bjtj smr wʿtj Snbj m3ʿ-ḫrw* 'throwing the throw-stick at the geese by the count, the sealer of the king of Lower Egypt, the sole companion, Senbi, the justified'. The artist has been particularly accurate in his depiction, showing the moment that Senbi succeeded in hitting a pintail duck with his weapon, causing it to plummet downward. Standing before the tomb owner is his wife, who watches her husband's activities while holding a duck in one hand and two lotus flowers in the other. The text above her describes her as: *ḥmt.f st-jb.f Mr.s nbt jm3ḫ* 'his wife, his favourite, Meres, the possessor of veneration'.

Like the upper section of the wall, the lower section to the right of the fowling activity is divided into two registers of equal height. Heading the top register (from left) are four men carrying gifts to Senbi. The first leads a common crane while carrying a smaller crane under his left arm and grasping its long beak. The text before him says: *n k3.k snw n(w) sḫt* 'for your ka, the offerings of the field/marshes'. The second man brings numerous ducks/geese tied by the feet and suspended from a yoke carried over his shoulders (ten birds on the left and eight on the right). Despite their constraints, the lively birds peck at one another and at the man's kilt. The action is described as: *inw n ḥb n k3w.k* 'the product of the catch for your kas'. The third man also uses a yoke to carry two cages full of small, unidentified birds. The label before him reads: *inw n sḫt n k3w.k* 'the product of the field/marshes for your kas'. The fourth man holds fruit and

120 Compare with Blackman, *Meir* 4, pls. 7, 17; Kanawati, *Meir* 1, pls. 80-81; Blackman, *Meir* 5, pls. 24, 28; Kanawati and Evans, *Meir* 2, pls. 84, 88; Blackman, *Meir* 6, pl. 13.

121 Newberry, *Beni Hasan* 1, pls. 32, 34; Newberry, *Beni Hasan* 2, pl. 11; Kanawati and Evans, *Beni Hassan* 1, pls. 132, 136.

122 Blackman, *Meir* 2, pl. 4.

123 Blackman, *Meir* 3, pl. 6; vol. 6, pl. 13.

124 Gamer-Wallert, *Fische und Fischkulte*, 24–27; Brewer and Friedman, 77–79.

125 Gamer-Wallert, *Fische und Fischkulte*, 39; Brewer and Friedman, 74–75.

flowers on a tray in one hand and, in the other, a bunch of papyrus stalks. Of his caption only *n k3w*[.*k*]... now remains.

Riverine activities take place nearby, although probably in the shallow water near the river's edge, as the stream is well below the knees of a man who uses a hand net to catch an impressive haul of fish. The fisherman, who is shown naked and with receding hair, is exerting great effort in lifting the packed net; leaning slightly backwards, his belly appears expanded perhaps due to strain. In front of his face is written: *šdjj mḥjjt n p3 ḥr k3* 'a catch of fish has been taken for the one with a ka'.[126] The fish in both his hand net and in the waters below are well drawn, but less so in a bag that he also carries, which possibly contains an earlier catch.

Two papyrus boats with three men on each are then engaged in what is assumed to be a mock fight.[127] All the men are naked, except for some who wear a belt around their waist. One man in each boat punts the vessel forward, while their colleagues are engaged in the fight, using a pole or an oar. A third man who crouches in the boat to the left has the same features as the emaciated Beja(?) herdsman shown on the south wall, i.e. having bushy, irregular hair, very thin limbs, and clearly visible chest bones. The third man in the right-hand boat is stretching forward, possibly trying to snatch a basket belonging to the opposing team. In the band of water below the boats a Nile crocodile (*Crocodylus niloticus*)[128] lurks on the riverbed and many well rendered fish can also be seen, including: binny (*Barbus bynni*),[129] a tilapia, a Nile perch, an eel (*Anguilla vulgaris*),[130] and a clarias catfish (*Clarias lazera*).[131] The men's shouts are recorded. Thus the first man in the left boat says: *wd r.k dj.j m3.f sw* 'you order, and I will make him see it'. The crouching man responds: *m3.n.tn ḥrdw* 'you have seen, O children!', while the cry of the last man is only partly preserved: *d3j*[*r*] ... 'subdue ...'. The dialogue between the men on the right boat may explain their actions. The man in the prow is navigating the boat away from the opposing one, yet shouting to his companion in the stern of the boat and who is snatching the basket from their adversaries: [*n*]*ḥm r.k* 'take (it) away'. The other responds: *ḫn r.sn rt*... 'propel towards them...'. The other scenes in the register are mostly damaged, but from what remains it appears that the depicted activity was the catching of birds with a clap net, as indicated by a peg fixed to the ground, a coil of rope around it, small shrubs, and the legs of birds.

The bottom register is reserved for agricultural activities relating to the two important crops of flax and barley. To obtain better fibres, the flax was usually harvested earlier than barley, while the stems were still green and soft.[132] As the scene progresses from left to right, placing the flax harvest first may indicate that it was chronologically earlier. Indeed, the artist has been very observant as the flax stems are

[126] This may mean 'for the lucky one', see Blackman, *Meir* 1, 29 n. 1.

[127] For studies of this fight see Vandier, *Manuel* 5, 510ff; Harpur, *Decoration*, 153-55. For some Old Kingdom examples see Wild, *Ti* 2, pl. 111; Varille, *Ni-ankh-Pepi*, pls. 5-6; Kanawati, *Teti Cemetery* 8, pls. 17, 48; Lashien, *Kahai*, pls. 23-25, 81-82.

[128] Vernus and Yoyotte, *Bestiare*, 209-40.

[129] Gamer-Wallert, *Fische und Fischkulte*, 9; Brewer and Friedman, *Fish and Fishing*, 59.

[130] Gamer-Wallert, *Fische und Fischkulte*, 12-13; Brewer and Friedman, *Fish and Fishing*, 71.

[131] Gamer-Wallert, *Fische und Fischkulte*, 10; Brewer and Friedman, *Fish and Fishing*, 60-61.

[132] Siebels, *Agriculture*, 118-19.

rendered in green paint, while those of the barley are yellow. Two men are facing one another; one pulls the flax from the ground and the other holds high a sheaf, trying to adjust the stems or to pick out unwanted ones. Addressing his companion, the latter says: *mk tw ḥr wḥȝ nn ṯȝwt nfr hrw* 'behold, you are plucking, not gathering; the day is beautiful'. His companion responds: *ḫȝȝ ꜥ.k dj.k mȝȝ n.n* 'free (?)[133] your hand, then give a glance at us'. Nearby, a man uses a hoe to break the hardened lumps of earth, but the text describing his action or words is too fragmentary to translate. Behind him, a workman sows grain from a basket that he carries, although only a small part of the container has survived. Two farmhands can then be seen ploughing, one leading the team of oxen using a tree branch as a stick, while the other, partly missing, is probably pressing the plough blade into the ground. The first man calls on the animals: *m ȝb tw nfr hrw* 'do not stop, it is a beautiful day', and the man behind him adds: *jw.f ḥr.s* 'it is on it'.

Behind the plough team, two men are depicted harvesting the barley using sickles, but the text written between them is mostly damaged. These are followed by two men who winnow the grain, one tossing it up using flat scoops and the other sweeping the fallen particles into a heap. They both wear a head-cover to protect their hair from the chaff. The last theme in the register is that of the threshing floor, where a small herd of cattle[134] are driven round the raised platform by a man brandishing a tree branch who shouts: *nfr.wj kȝw mn m jt r ḏr [bȝ]jjt.sn* 'how beautiful are the bulls sticking fast in the barley till the end of their bundles'.[135] At the extreme right of the register is a man holding a fork with which he appears to rake the threshed barley.

STATUE SHRINE (Pls. 2, 74a)

Positioned at the end of the central passage, which starts at the tomb entrance, the statue shrine projects from the west wall, rather than being cut deep into it. It is painted inside and out to imitate red granite, with the entrance of the structure surrounded by a torus moulding and surmounted by a painted cavetto cornice. The presence of a pivot-hole in the preserved upper-right corner of the entrance indicates that it was once provided with a door, possibly two-leaved, which opened outwards. A line of blue incised text is inscribed in the space between the torus moulding and the mouth of the doorway. The inscription starts in the centre and read to the right: *Nbt-ḥwt ꜥ.wj[.t] ḥȝ Wsjr ḥȝtj-ꜥ Snb.j pn mȝꜥ-ḫrw* 'O Nephthys, your arms are behind this Osiris, the count, Senbi, the justified', and to the left: *ȝst stp-sȝ.t ḥr ḥȝtj-ꜥ Snb.j pn n ḏt* 'O Isis, your protection is over this count, Senbi, for ever'. A vertical inscription on the right jamb reads: *jrj-pꜥt ḥȝtj-ꜥ ẖrj-ḥbt ḥrj-tp …*'the hereditary prince, the count, the chief lector priest, …', while only the signs for *jrj-p[ꜥt] …*'the hereditary prince, …' now remain on the left jamb.

133 The word as written is unattested (see Erman and Grapow, *Wörterbuch* 3, 228; Faulkner, *Dictionary*, 183-184) and the translation is tentative.

134 Although the accompanying text mentions 'bulls', one of the animals is clearly a cow.

135 See also Blackman, *Meir* 1, 30 n. 2.

THE TOMB OF WEKHHOTEP I
No. B2

I THE TOMB OWNER, HIS FAMILY AND DEPENDENTS

The Tomb Owner

NAME

Wḫw-ḥtp(.w) [136] 'Wekhhotep'.

According to Egyptian customs, Wekhhotep I was named after his grandfather, for we know that he was the son of Senbi, son of Wekhhotep.[137]

TITLES

1- *jmj-r ḥmw-nṯr* 'overseer of priests'.[138]
2- *jmj-r ḥmw-nṯr n nbt-r-ḏr* 'overseer of priests of the lady-of-all'.[139]
3- *jmj-r ḥmw-nṯr n Ḥwt-ḥr nbt Ḳjs* 'overseer of priests of Hathor, lady of Qusiya'.
4- *jrj-pꜥt* 'hereditary prince'.[140]
5- *wꜥb ꜥꜣ n nbt pt* 'chief *wꜥb*-priest of the lady of the sky'.[141]
6- *rḫ nswt mꜣꜥ mr.f* 'true acquaintance of the king, whom he loves'. [142]
7- *rḫ nswt ḥsjj.f wn mꜣꜥ* 'acquaintance of the king, truly favoured by him'.
8- *ḥꜣtj-ꜥ* 'count'.[143]
9- *ḥm-nṯr n nbt tꜣwj* '*ḥm-nṯr*-priest of the lady of the Two Lands'.
10- *ḥrj-sštꜣ n mꜣꜣt wꜥ* 'privy to the secrets of seeing alone'.[144]
11- *ḥrj-tp ꜥꜣ n Nḏft* 'great overlord of the UE 14'.[145]
12- *ḫw wꜥ jwtj snw.f* 'sole protector, without equal'.[146]
13- *ḫrp nbw* 'controller of gold'.[147]
14- *ḫrp šndyt nbt* 'controller of every kilt'.[148]

[136] Ranke, *Personennamen* 1, 84:9.
[137] Blackman, *Meir* 1, pl. 9.
[138] Ward, *Index*, 35(259); Jones, *Index*, 171[651].
[139] Ward, *Index*, 36(267).
[140] Ward, *Index*, 102(850); Jones, *Index*, 315[1157].
[141] Ward, *Index*, 79(650).
[142] For *rḫ nswt* see Ward, *Index*, 104(857a). For the reading as *iry ḫt nzwt mꜣꜥ* 'true custodian of the king's property', see Jones, *Index*, 330[1214].
[143] Ward, *Index*, 104(864); Jones, *Index*, 496[1858].
[144] Ward, *Index*, 121(1018).
[145] Ward, *Index*, 124(1058).
[146] For other titles with *ḫw* see Ward, *Index*, 131-32(1123-1124).
[147] Ward, *Index*, 134(1149); Jones, *Index*, 722[2630].
[148] Ward, *Index*, 137(1176); Jones, *Index*, 751[2737].

15- *ḫtmtj-bjtj* 'sealer of the king of Lower Egypt'.[149]
16- *ḫrj-ḥbt ḥrj-tp* 'chief lector priest'.[150]
17- *s3 jr ḥr-ḥ3t* 'son of he who acted formerly'.
18- *sm* '*sm*-priest'.[151]
19- *smr wʿtj* 'sole companion'.[152]
20- *sš md3wt ntr* 'scribe of divine records'.[153]

Wife of Wekhhotep

NAME

Ḏḥwtj-ḥtp(.w)[154] 'Djehutihotep'.

TITLE

nbt-pr 'lady of the house'.

Djehutihotep appears with her husband a number of times, always equal in size, and is depicted in front of him on the north wall.

Father of Wekhhotep

NAME

Snb.j[155] 'Senbi'.

Dependents of Wekhhotep

1- *Jjj*[156] 'Iy'.
2- *Jj-n(.j)*[157] 'Iyni'. *jmj-r ḥwt-ntr* 'overseer of a temple'.[158]
3- *ʿnḫ*[159] 'Ankh', son of *Ḥnw šrj*[160] 'Henu the younger, son of *Jḳrw*[161] Iqeru'. *wt* 'embalmer'.[162]
4- *Wḫ-nḫt*[163] 'Wekhnakht'.

[149] Ward, *Index*, 170(1472), where it is read as *sd3w.ty bi.ty*; Jones, *Index*, 763[2775].
[150] Ward, *Index*, 126(1076); Jones, *Index*, 784[2860].
[151] Ward, *Index*, 168(1465); Jones, *Index*, 885[3241]. The reading *stm* is also possible.
[152] Ward, *Index*, 151(1299); Jones, *Index*, 892[3268].
[153] Ward, *Index*, 161(1388); Jones, *Index*, 857[3132].
[154] Ranke, *Personennamen* 1, 408:18.
[155] Ranke, *Personennamen* 1, 313:23.
[156] Ranke, *Personennamen* 1, 7:17.
[157] Ranke, *Personennamen* 1, 9:25.
[158] Ward, *Index*, 34(250).
[159] Ranke, *Personennamen* 1, 62:19.
[160] Ranke, *Personennamen* 1, 242:3
[161] Ranke, *Personennamen* 1, 47:25.
[162] Ward, *Index*, 90(754).

5- *Ḥnw*[164] 'Henu', son of *Rns.j*[165] 'Rensi'. *jmj-r w n ḥwt-nṯr* 'overseer of the district of the temple'.[166]

6- *Ḥnw šrj* 'Henu the younger, son of *Jḳrw* Iqeru'. *wt* 'embalmer'.

7- *Ḥnmw*[167] 'Khnum'. *ẖrj-ḥbt* 'lector priest'.[168]

8- ...-*nw*. '...nu'.

Unnamed Dependents of Wekhhotep

1- *jmj-r rḫtjw* 'overseer of washermen'.[169]

2- *jrj ṯbwtj* 'keeper of the sandal-bag'.[170]

3- [*w*]*ḥmw* 'herald'.[171]

II THE DATE OF WEKHHOTEP I

See discussion under 'II The Date of Senbi I', above.

Suggested date: Reign of Senwosret I.

III ARCHITECTURAL FEATURES

Pls. 33, 81

The rock-cut tomb of *Wḫ-ḥtp* (B2) lies to the immediate south of B1, the tomb of *Snbj*. It comprises a single, pillared chamber with a shrine, a sunken pathway, and two burial shafts. Tomb B2 is approached by a forecourt formed by cutting back the rock slope 2.16m on the northern side and 1.90m on the southern. Its western side forms the façade of the chapel, giving it an eastern aspect. The façade, which has been left rough and undecorated, is 4.27m wide. The exterior of the jambs project .01m from the façade surface and are dressed smooth.

The chapel doorway is centred in the façade, though off-set by .77m to the north of the E-W central axis, possibly to provide floor space to cut Shaft I. The doorway is 1.15m wide x .53m deep; the height is unknown as the jambs are not well preserved.

[163] Ranke, *Personennamen* 1, 84:7.

[164] Ranke, *Personennamen* 1, 242:2.

[165] Ranke, *Personennamen* 1, 224:21.

[166] Ward, *Index*, 18(98).

[167] Ranke, *Personennamen* 1, 275:5.

[168] Ward, *Index*, 140(1202); Jones, *Index*, 781[2848].

[169] Ward, *Index*, 33(238); Jones, *Index*, 160[615].

[170] Ward, *Index*, 67(553).

[171] Ward, *Index*, 89(741).

The doorway has a threshold 2.80m wide x .06m high on the forecourt side and projects .28m from the façade. It is finished with a .05m wide x .06m high bevelled edge. On the chapel side of the threshold runs a 1.13m long x .13m wide x .13m deep channel with a .37m radius x .31m deep pivot recess on its southern end to accept an inward opening door. The only original chapel ceiling is at the western end; therefore, it can only be assumed that there would have been a reciprocal ceiling pivot hole.

From the entrance, the sunken pathway is 2.14m long x 1.79m wide, including four steps that rise by .28m, .09m, .09m, and .07m to the chapel floor, which has been left rough and uneven with a W-E slope, especially along the central axis.

Located 3.45m from the western wall are the remains of two square sectioned pillars. The best preserved is the northern pillar, which is decorated with standing figures of the tomb owner. Its preserved measurements are .59m N-S x .61m E-W x 1.81m. Little of the southern pillar remains; most likely it would have been decorated in a similar manner. Its base measures .63m N-S x .59m E-W.

While the wall preservation is poor, especially the eastern sections, it seems that the chapel walls were all decorated. The chapel's wall lengths vary slightly: the south wall measures 9.90m, the north wall 9.52m, the east wall is 7.28m, and the west wall is 7.53m. The width of the chapel increases slightly 6.15m from the N-E corner. The height of the extant ceiling is 2.75m and 2.65m directly in front of the shrine.

The decorated shrine is cut into the centre of the western wall. The doorway is defined by .42m wide jambs, each having a .47m wide footing that projects .40m into the chapel. The jambs contain two vertical columns of inscriptions painted blue, with a cavetto cornice above the shrine entrance. Undecorated areas associated with the shrine are coloured pink to imitate granite; a Coptic cross is painted on its southern wall. The shrine measures 1.15m N-S x 1.19m E-W x 2.16m high, with a floor raised .08m high and set .46m back from the exterior of its jambs. Cut in front of the shrine floor is a .085m wide x .035m deep groove with pivot holes at either end. This indicates that the shrine could be closed by a two-leaved, outward-opening door. There is no evidence of engaged statuary, however the western wall contains a figure of the tomb owner at an offering table. Before the entrance to the shrine is a shallow pit, .65m N-S x .52m E-W, cut into the floor and aligned between the jamb footings.

IV BURIAL APARTMENTS

Pl. 82

The chapel contains two burial apartments reached by vertical shafts cut into the floor. Both have been cleared previously.

I. Shaft I is located in the SE corner, cut at a slight NW diagonal. On the south wall near Shaft I two recesses are cut into the wall. The western most recess is .20m from

the western edge of the shaft; it is .24m above floor level and measures .28m long x .24m high x .18m deep. The easternmost recess, which is .12m above floor level, measures .18m long x .25m high x .22m deep. Shaft I's rectangular mouth measures 2.75m N-S x 1.54m E-W. The shaft descends 14.25m where further cutting to the south formed an irregularly shaped chamber, 2.76m wide at its mouth, 3.40m at its widest point x 3.55m long on its eastern side x 2.40m high. The floor is level.

II. Shaft II, probably that of *Wḫ-ḥtp*, abuts the centre of the north wall. Its rectangular mouth measures 3.38m N-S x 1.63m E-W. Three edges of the shaft are castellated. As with Shaft I, there are two recesses in the wall above the shaft. The westernmost recess is .24m above the floor and measures .32m long x .26m high x .19m deep. The easternmost recess is .23m above the floor and measures .39m long x .26m high x .20m deep. Shaft II descends 17.50m; the burial chamber is cut to the south, 1.00m above the floor of the shaft. It is accessed over a .25m high ridge across the chamber opening. The chamber measures 3.50m N-S x 2.90m E-W x 2.20m high, and its floor has a slight slope. Along the length of the eastern wall runs a roughly cut ledge of varying width .92m to 1.0m wide x .50m high, as well as a niche .85m deep x .90m high with a roughly cut recess in the SE corner.

V SCENES AND INSCRIPTIONS

The Chapel

Work on the decoration of the chapel was clearly abandoned at an early stage. This is particularly evident on the north and east walls where some parts of the scenes are executed in relief, while others show the drawings with an overlapping square grid and sections executed in relief at different stages of completion. It is presumed that all the scenes and inscriptions throughout the chapel were meant to be sculpted in raised relief and ultimately painted in bright colours, but the only complete part of the tomb is the shrine. There, a black dado is separated from the scenes by two bands of red and yellow delineated by thick black lines. In order to draw individuals and objects in different sizes, the artist used grids of different dimensions on the same wall and within the same scene. While the grid is mostly formed of squares, the sides are sometimes unequal. Thus, on the west wall, grids of the following measurements are used: 5mm x 6mm, 16mm x 16mm, 22mm x 22mm, 23mm x 23mm, 24mm x 24mm, 30mm x 30mm, 21mm x 41mm; while on the north wall the grids measure 15mm x15mm, 21mm x 21mm, 24mm x 25mm, 25mm x 25mm, 43mm x 43mm, 74mm x 74mm.

EAST WALL

North of Entrance (Pl. 83c)

The upper part of the east wall is damaged, and the scenes on the lower part, which were poorly preserved when Blackman recorded them, have since suffered further. In

describing its contents, Blackman's record was taken into consideration.[172] Wekhhotep I and his wife were originally depicted in equal size. Wekhhotep wore a collar and a short, projecting kilt and held a staff with one hand and a bunch of lotus blossoms in the other. His wife wore a long wig, bracelets, anklets, and a long, tight dress with shoulder straps, clasping a single lotus flower in one hand while holding her husband's hand with the other. Behind them were three attendants, probably all females, two of whom were originally carrying cosmetic items. According to Blackman, one of the girls is described as: ꜥȝmt 'Aam-slave',[173] but this reading remains uncertain.[174]

South of Entrance (Pl. 83a-b)

The wall surface was prepared to receive decoration that was never completed. Almost in the centre of the wall is a well-executed sketch in red of two men and a donkey (*Equus asinus asinus*)[175] with a basket on its back. Another graffiti showing a sailing boat is poorly drawn in black and may be much later in date.

SOUTH WALL (Pls. 34-47, 84-86)

The west end of the south wall is divided into two sections of equal height. The upper one is reserved for a representation of the tomb owner, while the lower part shows him standing with his wife. The space immediately in front of the couple is divided into two registers, but further along the wall a hunting scene expands to allow a third register. While this innovation creates a disorganised impression it corresponds, if somewhat clumsily, with the distribution of animals in the desert scene in the neighbouring tomb of Senbi. In general, the work on this wall is in many parts unfinished and, apart from certain figures such as that of a Beja herdsman who possibly intrigued the artist, the work appears to have been executed in haste.

The right, upper section of the wall is occupied by a figure of the tomb owner seated at an offering table. He wears a shoulder-length wig, a collar, and a short kilt with an apron and sits on a chair with a low, cushioned back and lion's legs. Holding a folded cloth in his left hand, he extends his right towards the table laden with twelve half-loaves of bread/reed leaves. Above, under, and on the opposite side of the table a variety of offerings are represented, including different cuts of meat (such as the forelegs, ribs, and heads of different animals), fowl, vegetables (such as lettuce and onions), fruits (such as grapes), lotus flowers, beverage jars, a censer, the seven sacred oils, and two bags presumably for black and green eye-paint. Between Wekhhotep's legs and the table stand is written: *dbḥt ḥtpt n kȝ n jmȝḫjj ḥȝtj-ꜥ Wḥw-ḥtp(.w)* 'requirement of offerings for the ka of the honoured one, the count, Wekhhotep'. Above the figure is a line of text that extends further along in the top part of the wall, but was never completed. It reads: *ḥtp dj nswt dj Wsjr dj Ḏḥwtj jtrt Šmꜥw Mḥtjw Psḏt ꜥȝt jmjt Jwnw nṯrw nbw jr.sn n.k ḫt ḫft sš pn rdj.n Ḏḥwtj m pr mdȝt-nṯr ꜥwj.j dj.sn bš.s wꜥb.f Jnpw*

[172] Blackman, *Meir* 2, pl. 5.
[173] Blackman, *Meir* 2, 15, pl.5.
[174] See Mourad, *The Hyksos*, 94-95.
[175] Osborn and Osbornová, *Mammals*, 134-136; Vernus and Yoyotte, *Bestiare*, 459-470.

wdn.f … 'an offering which the king gives, which Osiris gives, and which Thoth gives. May the southern and northern conclave/[176] chapels,[177] the great ennead which are in Heliopolis and all the gods make offerings for you in accordance with this writing which Thoth has placed in the house of the divine records, and my two hands caused it to be uttered/ recorded, and Anubis purified and offered, …'.

The above inscription probably refers to the following offering list, with the written and/or pronounced words having the potency to benefit the deceased. Two parts of the list are written, with the middle section, if it was ever inscribed, now blank; a poorly drawn graffiti in this space, which shows a sailing boat painted in red, may be much later in date. It appears that two sculptors worked at opposite ends of the list, with their work failing to be completed, like many other parts of the decoration, presumably due to the death of the owner. This conclusion may also be supported by the fact that the style of modelling is different in the two sections, with the right one, the closest to the tomb owner's figure, being the more accomplished. Each item in the list is written in a separate compartment, with a determinative and the required number in two smaller compartments beneath it. These items are (from right to left):[178]

1- *mw s3t sdt sntr kbhw t3wj* 'libation water, lighted incense, libation water, and two balls of natron (two)
2- *Nhb t3 Šmˁw* 'balls of Upper Egyptian natron of El-Kab' (five)
3- *sntr t3 dj m st.f* 'ball of incense, put in its place' (one)
4- *psš n kf* 'instrument [for opening the mouth]' (one)
5- *bj3 šmˁj mhwj sb* 'Upper and Lower Egyptian divine-tools of metal [for opening the mouth]' (two)
6- *srw škw* '*srw*-grain and *škw*-grain'[179] (four)
7- *mhr mjn jrtt* '*mhr*-jar and *mjn*-jar of milk' (one)
8- *mns3 dj kbhw šdj r mht* '*mns3*-jar, giving libation issued from the Delta' (two)
9- *h3ts m f3jt mnw hd km* '*h3ts*-jar(s) for carrying, of white and black stones' (two)
10- *p3t nt wdn wpt m gs.wj* 'offering bread divided into two halves' (two)
11- *hdw t3* 'onion bulbs'[180] (five)
12- *dsrt ˁ3t f3jt hft-hr* 'strong ale brought before (you)' (one)
13- *htp ˁ3 dptj* 'large offering table and *dptj*-bread' (two)
14- *3h* '*3h*-bread/pastry'[181] (four)
15- *shn* 'kidney' (one)
16- *hnwt nt mnw hd hr jrp* 'jar of white stone with wine' (one)
17- *hnwt nt mnw km hr hnkt* 'jar of black stone with beer' (one)
18- *hnwt nt bj3 hr hnkt* 'jar of metal with beer' (one)
19- *hnwt nt htm hr hnkt* 'jar of *htm*-material[182] with beer' (one)

[176] Faulkner, *Dictionary*, 33.
[177] For *itrt* see Hannig, *Wörterbuch* I, 236.
[178] For the reading of some of the following items see Barta, *Opferliste*, 79, 94-96, 102-103.
[179] Two types of grain were used in the opening of the mouth ceremony (Barta, *Opferliste*, 79-80; Hannig, *Wörterbuch* I, 1168.
[180] Hassan, *Gîza* 6:2, 196.
[181] Hassan, *Gîza* 6:2, 205.
[182] Hannig, *Wörterbuch* I, 911.

20- *stj-ḥb* 'stj-ḥb-oil' (one)

21- *ḥknw* 'ḥknw-oil' (one)

22- *sft* 'sft-oil' (one)

23- *nḫnm* 'nḫnm-oil' (one)

24- *tw3wt* 'tw3wt-oil' (one)

25- *ḥ3t[t nt ʿš]* 'best cedar oil' (one)

26- *ḥ3tt nt [ṯḥnw]* 'best Libyan oil' (...)

27- *w3ḏw ʿrf* 'bag of green paint' (...)

28- *[msdmt]*[183] *ʿrf* 'bag of black paint' (one)

29- *Wnḫwjj* 'two cloth strips' (two)

30- *ḥt snṯr ḳbḥw t3[wj]* 'lighted incense, libation water and [two] balls of natron' (two)

31- *ḥ3wt dj prt-ḫrw* 'offering table and the giving of invocation offerings' (four)

32- *j mj ḥr ḥtpwj nswt* 'O, come, carrying royal offerings'[184] (four)

33- *ḥtpwj jmj wsḫt* 'offerings, which are in the *wsḫt*-hall' (...)

34- *ḥms jgr prt-ḫrw* 'sit down and be silent[185] offerings' (two)

35- *nḫrw* 'nḫrw -bread' (two)

36- *t...* '...-bread' (two)

37- *t-rtḥ* 'rtḥ-bread' (four)

38- *ḏsrt nmst* 'nmst-jar of *ḏsrt*-beverage' (one)

39- *ḥnḳt ḥnms* 'ḥnms-beer' (one)

40- *jrp ʿbš* 'ʿbš-jar of wine' (two)

Inscription missing.

41- *ʿgwt nt sw[t]* 'preparation of wheat' (four)

42- *ʿgwt nt jt* 'preparation of barley' (four)

43- *b3b3wt ʿ* 'bowl of b3b3wt-fruit' (two)

44- *nbs ʿ* 'bowl of nbs-fruit' (two)

45- *t nbs ʿ* 'bowl of nbs-bread' (two)

46- *wʿḥ ʿ* 'bowl of carob beans' (two)

47- *d3bw ʿ* 'bowl of figs' (four)

48- *j3rrt ʿ* 'bowl of grapes' (four)

49- *ḥt nbt bnrt* 'every sweet thing' (...)

50- *rnpjjt nbt* 'all the year-offerings' (...)

51- *ḥnḳt nbt* 'all ḥnḳt-offerings' (four)

52- *w3ḥ gsw* 'lay down the half-loaves' (four)

53- *pḫr pdjjw* 'pḫr-offerings and pdjjw-offerings' (four)

54- *stpt* 'the choice things' (four)

55- *ḥ3t wdḥw* 'the best of the offering table' (four)

The offering list is followed by a text written in thirteen vertical lines, which reads: (1) *jw wʿb jw ḥwjj nn* (2) *r-3w n Wsjr ḥ3tj-ʿ Wḥw-ḥtp(.w) pn ʿḥʿ* (3) *ḥms r t ḥ3 ḥnḳt ḥ3.k k3 ḥ3 3pd ḥ3* (4) *3šrt ḥ3 šbwt.k m nmt nṯrt ḥtm* (5) *s3 nṯr m ḥtpw-nṯr.f ḥtm s3 ḥ3tj-ʿ*

[183] Only the determinative was used to write this common item. See also Kanawati and Evans, *Beni Hassan* 1, pl. 138.

[184] For a different reading see Hassan, *Gîza* 6:2, 276-277.

[185] This appears to be the name of a food item.

(6)*Wḥw-ḥtp(.w) pn m ḥtpw*[186]*.f pn jj.tj*(7)*n bȝ.k Wsir ḥȝtj-ᶜ Wḥw-ḥtp(.w) bȝ jmj* (8) *bȝw.f sḥm jmj swt.f ḥtpw n bȝ jmj ȝḥw.f*[187] (9) *n sḥm jmj swt.f n* ᶜ *ᶜwȝjjw* (10) ... *rsw jtjj* (11) ... *Ḥr nb pᶜt* (12) *ššp.n.k jw wᶜb ḥȝtj— jmj-r* [*ḥmw-nṯr*] (13) *S*[*n*]*bj sȝ Wḥw-ḥtp(.w) mȝᶜ-ḥrw* 'all these pure and abundant (things) are (2) for this Osiris, the count Wekhhotep. Arise (3) and sit down to your thousand of bread, thousand of beer, thousand of oxen, thousand of fowl (4) and thousand of roasted joints, your food-offerings from the divine slaughterhouse. (5) As the son of a god is provided with his divine offering, so this son of the count, (6) Wekhhotep, is provided with this his offering. (7) Welcome to your soul, O Osiris, the count Wekhhotep, the soul who is in (8) his strength, the prevailing one who is in his places. Offerings for the soul who is in his power, (9) for the prevailing one who is in his places. No arm of a robber (10) ... vigilance ... take possession (11) ... Horus, lord of mankind, (12) that which you have received. It is pure, O count, overseer [of priests], (13) Wekhhotep, son of Senbi, the justified'.

Two men at the extreme left section of the register perform parts of the offering ritual. The first stands before an offering table and carries an object in each hand, while the second man gestures with one hand and carries a long cloth in the other, which, as suggested by Blackman, may have been used to remove their footprints at the end of the ceremony.[188] The inscription in front of the first participant is damaged, as are those above and behind his colleague, although the following can still be read: ... *sš mḏȝwt.f ḥr ᶜ.wj.f* '... the writing, his documents are upon his arms'.

The right part of the lower section of the wall depicts the tomb owner and his wife in equal size, standing and receiving offerings. Holding a staff and a sceptre, Wekhhotep wears a shoulder-length wig, a beard, a collar, bracelets, and a short, projecting kilt. His wife, Djehutihotep, stands behind him. Although her figure is now poorly preserved, Blackman's record[189] shows that she originally wore a long wig, a collar, bracelets, anklets, and a long, tight dress, and held a lotus flower in her left hand while placing her right hand on her husband's shoulder. A vertical line of text describing the activities that the tomb owner is viewing reads: *rdjt mȝᶜ ḥtpt ḏfȝw n ḥȝtj-ᶜ Wḥw-ḥtp(.w) mȝᶜ-ḥrw* 'Making presentation of offerings and provisions to the count, Wekhhotep, the justified', while the caption in front of the woman declares: *ḥmt*[*.f mrt.f nt*]*st-jb.f nbt-pr Ḏḥwtj-ḥtp(.w) mȝᶜt-ḥrw* 'his wife, [his beloved], his favourite, the lady of the house, Djehutihotep, the justified'.

Wekhhotep and Djehutihotep are approached by offering bearers placed in two registers. The first man in the upper register kneels and presents wine(?) in two *nw*-jars, an action usually performed before a god or a king. The caption in front of him reads: *n ḥȝtj-ᶜ Wḥw-ḥtp(.w) n kȝw.f* 'to the count, Wekhhotep, to his kas'. He is followed by a man carrying the foreleg of an ox, presumably just severed from the slaughtered animal depicted immediately behind him, where parts of the carcass are placed above the body

[186] This appears to be an error for *ḥtpw*. The *ḥtp*-sign was perhaps omitted and as a result the *p* was reshaped to appear as the determinative for the bread loaf.

[187] See Blackman (*Meir* 2, pl. 8) for the beginning of line 9.

[188] Blackman, *Meir* 2, 17. For a detailed study of this part of the ceremony see Altenmüller, *JEA* 57 (1971), 146ff.

[189] Blackman, *Meir* 2, pl. 6.

and the butcher is busy cutting the second foreleg. Behind the last is a Beja-like herdsman, with an emaciated body, bushy hair, unshaven face, and a tufted beard. He wears a brief kilt, possibly made of animal skin, holds a long tree branch as a staff, and leads three fattened oxen on ropes.[190] The artist demonstrated unusually high skill in rendering the features of this foreign man. He is assisted by an Egyptian herdsman holding a rope attached to one of the animals while using a stick to urge the herd to move. Next comes a herdsman leading a group of dorcas gazelles, who also uses a stick to move them, then another worker who carries a calf on his back, with its anxious mother following. Behind this is a detailed depiction of a cow suckling her calf. The mother turns back to lick the young animal on the rump,[191] her left horn shown in profile, while the calf flexes its forelegs slightly in order to reach the udder. Another large cow followed by a bull complete the register.

A label describing the action of the offering bearers in the bottom register reads: *n ḥ3tj-ʿ Wḥw-ḥtp(.w) m3ʿ-ḥrw n k3w.f* 'to the count, Wekhhotep, the justified, to his kas'. The first man presents four geese to the tomb owner, wringing the neck of one, while another is already dead on the floor. The second bearer supports a tray of food on his left shoulder and carries a beverage jar suspended by a cord from his right hand. Three women follow, all wearing long wigs; although the details of their dresses have not been added, their collar lines are clear. The first woman supports a basket of bread on her head and carries a pintail duck by the wings in her right hand. The second woman balances a bowl containing lotus flowers upon her head, while the third brings a toilet-box on her left shoulder and clasps a mirror in her right hand. An overseer who wears a long kilt and wields a baton follows the group.

The left part of the lower section of the wall depicts the tomb owner hunting in the desert using a bow and arrows. As this image and that in the neighbouring tomb of Senbi are the most developed desert hunting scenes at Meir, a comparison between them may be useful. Like Senbi, Wekhhotep is hunting actively and not a mere spectator, as found in many other desert scenes, particularly those of the Old Kingdom period.[192] Contrary to the scene in Senbi's tomb, however, there is no enclosure fence separating Wekhhotep from the wild animals, yet as the work on this wall was almost certainly left unfinished, such a fence may possibly have been planned. The tomb owner leans forward slightly, lifts himself on the toes of his right foot, and starts to draw the string of his bow, but his movements lack the energy exerted by Senbi; nevertheless, the scene is perhaps more realistic, as the latter appears somewhat off-balanced. Wekhhotep holds one spare arrow; Senbi holds two. Wekhhotep wears a simple sports tunic while Senbi's dress is more suitable for the hunt, with the addition of a tight girdle, perhaps necessary when effort was exerted. Following Wekhhotep is his attendant, dressed similarly to Senbi's helper, and like him he has a water skin hanging from his shoulder

[190] The object between the last animal's legs is unclear but it is probably the tail of its adjacent herd-mate.

[191] Licking is a common social behaviour in cattle, but is especially exhibited between cows and their newborn calves in order to establish a maternal bond. See von Keyserlingk and Weary, *Horm. Behav.* 52 (2007), 107-108.

[192] See references under Senbi.

and holds a quiver full of arrows. He does not carry a battle-axe, however, and instead grasps a spare bow.

The distribution of the desert animals appears chaotic, but this is probably the result of the scene being unfinished, with the desert terrain not marked. The animals thus appear to float in the space occupied by the bottom two registers. Like Senbi's artist, Wekhhotep's craftsman, assuming that they are different, seems to have tried to add a feeling of depth to the scene. The lack of marked terrain and the placement of some groups of animals at the same baseline level render the attempt less successful, however.

At top left, a hunting dog with a tightly coiled tail and wearing a collar has brought down an animal that has already been pierced by one of Wekhhotep's arrows. The species of the victim is difficult to discern, but its size, short legs, pricked ears, and elongated tail may suggest either a red fox[193] or a golden jackal (*Canis aureus*).[194] Indeed, to the right of this vignette, a jackal or fox with identical features lurks behind a long eared ungulate giving birth, biting the emerging calf on the muzzle; the long ears on the foetus suggest that the labouring mother is probably a wild ass (*Equus asinus africanus*).[195] Below this dramatic scene, two hunting dogs bicker over the fallen and wounded body of a dorcas gazelle, the hound on the right pulling backwards as it attempts to snatch the prey away from its colleague.

Immediately in front of Wekhhotep, a small hunting dog grasps a Cape hare in its jaws, the rodent's legs still outstretched, as though it has been caught mid-run. To the far right of this exchange is then displayed a variety of animals in a long, meandering row, with each motif isolated and seemingly unconnected to its neighbours. The first of these is an ambiguous animal with large, rounded ears, a long tail, and paws. Despite the presence of the latter, Blackman suggested that it is an okapi (*Okapia johnstoni*),[196] a hooved animal that, in addition, is not part of Egypt's native fauna. Others have subsequently proposed instead that it more closely resembles a Cape hunting dog (*Lycaon pictus*),[197] a species that is attested in Predynastic and Early Dynastic representations, but which subsequently disappeared from the Egyptian repertoire. To the right of this animal, a small jerboa (possibly a lesser Egyptian jerboa, *Jaculus jaculus*)[198] hops forward, while before it wanders a scimitar oryx calf. Two pairs of mating animals can then be seen, first Nubian ibex, where the female appears to spurn the male's ardour, and then dorcas gazelle, where the female holds her ground. The latter's behaviour is observed by a Cape hare that turns back to stare at the action, oblivious to a pair of lions, which also mate nearby. Like the leopards that copulate in Senbi's hunting scene, the lioness stands incorrectly instead of lying upon the substrate. Uniquely, however, the male bites the female's neck, a characteristic behaviour

[193] Blackman (*Meir* 2, 19) thought that a fox was possible, but ultimately proposed that the prey animal depicts a wild ass. For the representation of red foxes, see Osborn and Osbornová, *Mammals*, 68-72; Vernus and Yoyotte, *Bestiare*, 184-186.

[194] Osborn and Osbornová, *Mammals*, 55-57; Vernus and Yoyotte, *Bestiare*, 115-129.

[195] Osborn and Osbornová, *Mammals*, 132-134; Vernus and Yoyotte, *Bestiare*, 106.

[196] Blackman, *Meir* 2, 19.

[197] Blackman, *Meir* 2, 40. See also Osborn and Osbornová, *Mammals*, 79-80; Vernus and Yoyotte, *Bestiare*, 167.

[198] Osborn and Osbornová, *Mammals*, 51-52; Vernus and Yoyotte, *Bestiare*, 141.

exhibited during feline mating, which suggests that the artist had witnessed this feature firsthand.[199]

On the lower register, at far left, a hunting dog savages a wounded and collapsed scimitar oryx, thc dog's jagged teeth clamped on the ungulate's neck as it vocalises its pain and fear. Similarly, a larger dog attacks a Nubian ibex nearby, biting its muzzle and wrenching its head backward as it falls to the ground. Curiously, scimitar oryx are considerably larger than ibex and so the size difference depicted here is biologically inaccurate. Indeed, size seems to be unimportant as a reasonably well-drawn giraffe (*Giraffa camelopardalis*)[200] lacks height compared to the surrounding animals. Before it, a canid – possibly another Cape hunting dog – worries a deer (probably a Mesopotamian fallow deer, *Dama mesopotamica*), whose hind legs appear to be broken. Deer are represented rarely in Egyptian art and so its appearance here is notable.[201] Thereafter, an odd assortment of species can be seen. First a wild bull, then a male African lion that is preceded by a hartebeest with lyre-shaped horns. A lioness prowls at the end of the line, but behind her is yet another unique scene depicting a vervet monkey (*Chlorocebus pygerythrus*)[202] giving birth upon a small mound. The animal rests on all fours with her tail elevated and leans forward as both the head and arms of her young are delivered. Curiously, the monkey appears to have a short leash or collar around its neck.

WEST WALL

South of Statue Recess (Pls. 52-54, 88)

This section of the wall is divided into three registers. To the left of the top register, the tomb owner and his wife are seated together before an offering table laden with ten half-loaves of bread/reed leaves. It is noticed that the woman's body partly covers that of Wekhhotep, rather than vice-versa, which agrees with her prominence on the north wall (see below). Two tall vessels are placed under the table, while another jar and a variety of food items are piled on the opposite side. These include cuts of meat, a goose, onions, lettuce, grapes, and lotus flowers. Above the offering table a stand is represented with seven jars of oils, two bags probably containing black and green eye-paint, and three other uncertain objects. Behind the couple stands a maidservant carrying a mirror and its case in one hand and, originally, a perfume jar in the other.[203]

[199] See Evans, *Animal Behaviour*, 158-159.

[200] Osborn and Osbornová, *Mammals*, 148-151; Vernus and Yoyotte, *Bestiare*, 142-144.

[201] See Osborn and Osbornová, *Mammals*, 152-155; Houlihan, *JEA* 73 (1987), 238-243; Vernus and Yoyotte, *Bestiare*, 133; Kitagawa, *TMO* 49 (2008), 541-552. It is intriguing to note that two of the c. 30 known representations of deer occur in the funerary temple of king Sahure and the tomb of Ti, with which the tombs of Senbi I and Wekhhotep I also share other unique motifs (see text for details).

[202] Previously classified as *Cercopithecus aethiops*. See Osborn and Osbornová, *Mammals*, 39-41; Vernus and Yoyotte, *Bestiare*, 615-627.

[203] The last detail has disappeared since it was recorded by Blackman (*Meir* 2, pl. 15).

Facing the couple are six men, the first of whom is crouching on the ground and playing the harp,[204] while the remaining five stand wearing long kilts. The second man holds a baton and has his arms crossed over his chest, perhaps as a sign of greeting or respect. He is labelled: [w]ḥmw sṯꜣ jmj-r ḥwt-nṯr ḥnꜥ ḥnjjw[205] 'the herald, ushering the overseer of a temple together with the musicians'. Accordingly, the man who follows him and who carries a box with both hands is described as jmj-r ḥwt-nṯr Jj-n(.j) 'the overseer of the temple, Iyni'. The last three men wear menats and hold castanets, with the name of each written before him as follows: Wḫ-nḫt 'Wekhnakht', Jjj 'Iy' and …-nw. '…nu'.

The tomb owner, standing on the left, supervises the activities on the second and third registers. He is depicted with short hair or a skullcap, and wears a long kilt and a collar ending at the back in four long weighted pendants.[206] He holds a Wekh-emblem in one hand and a long, reed staff in the other. A horizontal line of text describes him as: jrj-pꜥt ḥꜣtj-ꜥ ḫw wꜥ jwtj snw.f ḥrj-sštꜣ n mꜣꜣt wꜥ jmj-r ḥmw-nṯr n nbt-r-ḏr jmꜣḫjj ḫr nṯrw jmjw ḫrt-nṯr ḥꜣtj-ꜥ Snb.j sꜣ Wḫw-ḥtp(.w) mꜣꜥ-ḫrw ḫr Wsjr nb ꜥnḫ ḫr Jnpw tpj ḏw.f 'the hereditary prince, the count, the sole protector, without equal, the privy to the secrets of seeing alone, the overseer of priests of the lady-of-all, the honoured one before the gods who are in the necropolis, Wekhhotep, son of Senbi, the justified before Osiris, lord of life and before Anubis who is on his hill'.

The space opposite him is divided into two registers. The top panel is occupied by one man and three women who each face Wekhhotep. Having short hair and dressed in a long kilt, the male carries four loaves of bread of two different types, as well as objects dangling from his hands, suggested by Blackman to be tongs with which he has removed the bread from the oven.[207] The text before him reads: n kꜣw.k snw n Ḥwt-ḥr ḥs.s tw swꜣḥ.s [t]w 'to your kas, the snw-offering of Hathor, that she may favour you and prolong your life'. The three women behind him wear long wigs and long, tight dresses with shoulder straps. Each is presenting Senbi with a sistrum and a menat-necklace used in the cult of Hathor. In front of the first woman is written: n kꜣw.k mnjwt nt Ḥwt-ḥr nbt Ḳjs ḥs.s tw 'to your kas, the menats of Hathor, lady of Qusiya, that she may favour you'. Before the second woman is written: n kꜣw.k mnjwt nt Ḥwt-ḥr swꜣḥ.s [t]w 'to your kas, the menats of Hathor, that she may prolong your life'. The inscription before the third woman reads: n kꜣw[.k] mnjwt nt mwt.k Ḥwt-ḥr sḫr.s ḫftj.k 'to your kas, the menats of your mother Hathor, that she may overthrow your enemy'. The remaining part of this register has been divided into square gridlines, but no figures or objects were drawn.

Standing in front of Wekhhotep in the bottom register, but facing away from him, is a man with short hair and wearing a collar and a transparent dress on top of a short kilt. He holds a long staff and is identified as: jmj-r w n ḥwt-nṯr Rns.j sꜣ Ḥnw 'the overseer of the district of the temple, Henu, son of Rensi'. With the tomb owner, he is watching a

[204] It is curious that his figure has suffered deliberate damage only in the eye area.
[205] The ḫn-sign is presumably used here instead of ḥn.
[206] Blackman suggests that the collar with the four pendants is perhaps two menats together (*Meir* 2, 24, n. 9).
[207] Blackman, *Meir* 1, 23; Blackman, *Meir* 2, 24.

46

fierce fight between two bulls in which each has pierced the neck of its adversary with its horns. A herdsman with a raised stick stands behind each bull and shouts out, but the meaning of their exclamations depends on whether they are thought to be aimed at separating the bulls or encouraging them to attack.[208] The following translation is thus tentative. The man to the left shouts *wpj k3w wpj ts jn k3 wpj* 'separate, bulls, separate, lift up, remove the bull, separate', while the one to the right calls out *sfḫ sfḫ hrw pw Wḫ ꜥ3 sfḫ* 'let go, let go today, the Wekh is great, let go'. It is possible that the fight between the two animals is over a cow that stands to the right. The latter paws at the ground with her left foreleg, a bovine threat display that is sometimes exhibited by cows as their fertility level increases.[209] The bulls may therefore be vying for mating access to the female.

North of Statue Recess (Pls. 48-51, 87)

Like the southern part of the west wall, the north section is divided into three registers. Apart from the standing figures of the tomb owner and his wife, and the herdsmen with animals in the bottom register, the remaining scenes and inscriptions are executed in black outline on top of red square gridlines of different dimensions, depending on the intended figures. To the right in the top register, the tomb owner is shown seated on a chair with a low, cushioned back and lion's legs. He wears a shoulder-length wig, a collar, bracelets, and a short, tight kilt while holding a folded cloth in his left hand and extending his right hand towards an offering table laden with ten half-loaves of bread/reed leaves. A horizontal line of text identifies him as: *jrj-pꜥt ḥ3tj-ꜥ ḫtmtj-bjtj smr wꜥtj jmj-r ḥmw-ntr sm ḫrp šndyt nbt ḫrj-ḥbt ḥrj-tp rḫ nswt ḥsjj.f wn m3ꜥ ḥ3tj-ꜥ Snb.j s3 Wḥw-ḥtp(.w) jkr m3ꜥ-ḫrw* 'the hereditary prince, the count, the sealer of the king of Lower Egypt, the sole companion, the overseer of priests, the *sm*-priest, the controller of every kilt, the chief lector priest, the acquaintance of the king, truly favoured by him, the count, Wekhhotep the excellent, son of Senbi, the justified'.

Placed around the table are beverage jars and heaps of food items, including bread, cuts of meat, geese, lettuce, onions, grapes, and figs, as well as incense. Between Wekhhotep's legs and the table stand is written *dbḥt ḥtpt n k3w n jm3ḫjj ḥ3tj-ꜥ Wḥw-ḥtp(.w)* 'requirement of offerings for the kas of the honoured one, the count, Wekhhotep'. Behind the tomb owner stand two men with short hair and long kilts. The first, an elderly man with rolls of fat across his chest and stomach, is labelled as *jrj tbwtj* 'keeper of the sandal-bag', while the second man is probably described as *[jmj-r rḫ]tjw* 'overseer of washermen'. Facing the seated tomb owner are five men, each with short hair and sashes - three standing in long kilts, while two kneel and wear short kilts. The first man pours libation water from a *ḥs*-jar. He is identified as: *wt Jkrw s3 Ḥnw šrj* 'the embalmer Henu the younger, son of Iqeru', and his action is described as *st mw jw wꜥb* 'pouring water, it is pure'. Behind the latter is his son who followed his father's career, thus he is labelled: *wt Jkrw s3 Ḥnw šrj s3 ꜥnḫ ḥr sntr* 'the embalmer Ankh, son of Henu the younger, son of Iqeru', carrying incense'. The men who kneel each raise their right arm and place their left hand on their chest. The last individual in the register is reading from a papyrus scroll while holding a broom in his right hand, possibly to end the

[208] See Kanawati, *BACE* 2 (1991), 51ff; Galán, *JEA* 80 (1994), 81ff.
[209] For this display see Evans, *Animal Behaviour*, 133-134.

ceremony by removing the footprints.[210] The ritual is labelled as: *šdt s3ḥwt ꜥš3t jn ẖrj-ḥbt Ḫnmw* 'reciting many glorifications by the lector priest, Khnum'.

The lower part of the wall is reserved for the receiving of offerings by the tomb owner and his wife (rendered in relief but with guidelines still visible). The pair stands to the right in equal height. Wekhhotep wears a shoulder-length wig, a collar, bracelets, and a short, projecting kilt while he grasps a staff in one hand and a sceptre in the other. His wife stands behind him wearing a long wig, a collar, bracelets, and a long, tight dress with shoulder straps while holding a bunch of lotus flowers in one hand and placing the other on her husband's shoulder. A horizontal line of text running the full length of the register identifies the tomb owner and his wife as *jrj-pꜥt h3tj-ꜥ ẖrj-ḥbt ẖrj-tp sš md3wt nṯr wꜥb ꜥ3 n nbt pt sm ḥm-nṯr n nbt t3wj s3 jr ẖr-ḥ3t h3tj-ꜥ Snb.j s3 Wḥw-ḥtp(.w) m3ꜥ-ẖrw m swt.f nbt ḥr smjt jmntjt [nt] ẖrt-[nṯr] jm3ẖjjt ḥmt.f mrt.f nt st-jb.f nbt-pr Ḏḥwtj-ḥtp(.w)* 'the hereditary prince, the count, the chief lector priest, the scribe of divine records, the chief *wꜥb*-priest of the lady of the sky, the *sm*-priest, the *ḥm-nṯr*-priest of the lady of the Two Lands, the son of he who acted formerly, the count, Wekhhotep, son of Senbi, the justified in all his places, before the western desert of the necropolis'. The rest of the line identifies the wife as: 'the honoured one, his wife, his beloved, his favourite, the lady of the house, Djehutihotep'.

The area of the wall opposite the couple is divided into two registers. Five men are depicted in the upper register, all having short hair and wearing short, tight kilts. The first man wrings the neck of a goose that he holds by the wings along with three pintail ducks. One of the latter bites the man's outstretched finger, while a fourth pintail lies dead at his feet. Addressing the tomb owner he says: *n k3w.k špsw Wḥw-ḥtp(.w) m3ꜥ-ẖrw* 'for your noble kas, O Wekhhotep, the justified'. The second man carries seven ducks suspended from a rope tied to their legs, some of which nip at one another. He also pins a common crane under his right arm, holding the bird's long beak in his hand to prevent it from attacking him. The caption before the man reads: *jnw n nbt ḥb n k3w.k* 'the gifts of the lady of the catch for your kas', in reference to the goddess *Sḫt* 'Sekhet'.[211] The third man brings two young dorcas gazelle in baskets suspended on ropes slung from a pole placed over his shoulders. The caption before him reads: *jnw n Sḫt n k3w.k* 'the gifts of Sekhet for your kas'. The following man leads a female scimitar oryx by the horns, with the accompanying caption reading *m3-ḥd h3w n k3w.k* 'thousands of oryx for your kas'. The last man in the row carries the oryx's calf, its four legs tied together to prevent its escape. The inscription before him reads: *bḥs.s n k3w.k špsw mrr Sḫt* 'its calf for your noble kas, O beloved of Sekhet'.

The line of inscription above the bottom register reads: *jrj-pꜥt h3tj-ꜥ jmj-r ḥmw-nṯr [n Ḥwt-ḥr nbt]Ḳjs ḏsr sšm m pr-wr mn rd(?) m st ḏsrt h3tj-ꜥ Wḥw-ḥtp(.w) m3ꜥ-ẖrw ḥr Wsjr* 'the hereditary prince, the count, the overseer of priests of Hathor, lady of Qusiya, the splendid of conduct in the Great House, the firm of foot in the sacred place, the count, Wekhhotep, the justified before Osiris'. Two men are represented in this register. The

[210] For this ceremony see Altenmüller, *JEA* 57 (1971), 146ff.

[211] For other references to the marsh goddess Sekhet, lady of the catch, see Davies, *Deir el-Gebrâwi* 2, pl. 5; Kanawati, *Deir el-Gebrawi* 3, pl. 57; Newberry, *Beni Hasan* 1, pl. 40; Kanawati and Evans, *Beni Hassan* 1, 59, pl. 135.

first displays the distinctive characteristics of Beja herdsmen, with visible ribs and collarbones, bushy hair, an unshaven face, and a tufted beard, who walks with the help of a short stick. A vertical inscription before him reads: *rdjt mȝ'w wḏwt nt ḥrt-jb n kȝw.k Wḫw-ḥtp(.w) nb jmȝḫ* 'presenting the offerings of the favourite byres to your kas, O Wekhhotep, the possessor of veneration'. The herdsman leads on a rope a long-horned ox, labelled *rn n jwȝ* 'prime ox'. A second ox, equally labelled, follows. At the left of the register is an elderly official, with short hair, a long kilt and rolls of fat across his chest and stomach. Identified as *wḥmw* 'herald', he holds a baton in his right hand. The inscription before him reads: *mȝ'w n Wḫw-ḥtp(.w) ḫrj kȝ m hrw pn* 'offerings for Wekhhotep, who possesses a ka today'.

NORTH WALL (Pls. 55-65, 89-92)

At the west end of the north wall are the standing figures of the tomb owner and presumably his wife. Wekhhotep leans on his staff in a relaxed manner, while the woman places her right hand on his right shoulder and holds a papyri-form staff. This type of staff,[212] which is often held by goddesses, is also attested with queens, such as Iput[213] and Wedjebten,[214] wives of king Pepy II. The rarity and importance of this type of staff may be demonstrated by the fact that it is only found in one of the well-documented Old Kingdom provincial tombs, namely, for the wife of Djau of Deir el-Gebrawi. Since Djau was nomarch of both Deir el-Gebrawi and Abydos, the name of his wife, Pepyankhnes,[215] may well suggest a relationship with royal in-laws at Abydos. It is possible, therefore, that the papyri-form staff was only held by women who had a royal background. It is interesting to note, therefore, that Wekhhotep's wife is not only shown of equal size to her husband but, contrary to tradition, is represented in front of him. Standing behind the couple in two superposed registers are two attendants, each wearing a long kilt and displaying rolls of fat across their stomach, perhaps as a sign of mature age.

The wall in front of the couple is divided into three registers of almost equal height. While the bottom register continues to the far end of the wall, the top two registers are interrupted twice by images of the tomb owner. Immediately before the couple in the top register and at their eye-level are four pairs of wrestlers performing different holds and movements. Parts of the scene are now missing as a result of flaws in the rock, which were originally covered with plaster, but Blackman's statement that the style in which the combatants are carved is 'crude in the extreme',[216] is unjustified. The relief here, as elsewhere in the tomb, is rather shallow, but well executed, with vigorous and realistic movements and unexaggerated muscular treatment.

[212] Seven cases from the Old Kingdom have been collected by Harpur, *Decoration*, 332 (6.12). It is difficult to examine the background of some of the listed women.

[213] Jéquier, *Neit et Apouit*, fig. 22.

[214] Jéquier, *Oudjebten*, fig. 3.

[215] Davies, *Deir el-Gebrâwi* 2, pl. 6.

[216] Blackman, *Meir* 2, 12.

Four men are depicted in the middle register carrying offerings to Wekhhotep. Presenting the haunch of a large animal, the first man says: *ḫpš n k3w.k* 'a foreleg for your kas'. The second man holds three pintail ducks, wringing the neck of one as another reaches up to bite his forearm. A fourth pintail is already dead upon the ground. The caption before the man says: *n k3w.k jnw nfr ḥ3t 3ḥt* 'for your kas, the beautiful gifts of the beginning/ the best of the Inundation season'.[217] The third man is badly damaged, as are the items he carries and the caption describing his action. The last man in the group carries loaves of bread on two trays supported on his shoulders.

A large seated figure of the tomb owner occupying the height of the top two registers is depicted in a central position on this wall. He wears a shoulder-length wig, a collar, bracelets, and a short kilt, holding a staff with one hand and a folded cloth in the other. Sitting on a chair with a low, cushioned back, and lion's legs, he is accompanied by a woman wearing a long wig, a collar, bracelets, and a long, tight dress with shoulder straps. She holds a lotus flower as she sits on the floor next to him, clasping his leg and looking up affectionately into his face. No surviving inscriptions inform us of the woman's identity, but she may well be his wife, although not necessarily Djehutihotep, who appears with him in equal size everywhere else in the tomb. An elderly attendant, with short hair, long kilt, and rolls of fat across his chest and stomach, stands behind the tomb owner.

In the top register opposite the tomb owner's face is an emaciated herdsman who closely resembles a man represented on the south wall in the tomb of Senbi I, father of Wekhhotep. In both tombs, he is depicted ahead of all other herdsmen and appears with unusually hunched shoulders and uses a short stick for support. He leads three large long-horned oxen that are encouraged to move by another herdsman behind them. Nearby, seven men try to bring down and bind a large ox. The scene is full of energy, with the men struggling against the strong animal, grasping its head, lower jaw, horns and legs, trying to overthrow it. The enraged animal protrudes its tongue as it vocalises its frustration and anger. Two of the men try forcefully to twist the animal's head around, with the one to the left saying: *ng* 'break up', while the one to the right addresses another who is pulling the animal's tail saying: *dj n.k sw ḥr gs.f* 'place it on its side'. A man at the far left holds a rope, ready to use it either to bring the beast down or to tie its legs together once it falls. His action is described as: *sph ng3w* 'lassoing the long-horned bull'. Further to the right is another group of men also grappling with an animal, but little remains of the scene.

In front of the couple in the middle register are three entertainers: a flute player, a harpist and a singer. It has been suggested that some blind musicians were deliberately selected, particularly when they had to perform in the presence of women.[218] While such a claim cannot be verified, it is interesting to observe that two of our entertainers, the harpist and the singer, appear to be blind (their eyes are closed and slit-like) and they also face towards the couple, while the flutist, whose eyes are opened, sits with his back to them. To the right of the entertainers is a scene of fowling with a clap net. Five

[217] Blackman translates this as 'the first-fruits of the marshlands' (*Meir* 2, 12). It seems more likely that this is a reference to the Inundation season, during which fowling was common.
[218] Blackman, *Meir* 2, 12-13.

naked men are involved; four are pulling the rope attached to the net, the end of which is fastened to a peg driven into the ground, while the fifth, a signalman hiding behind a screen of papyrus plants, has just given them the order to act by using a cloth stretched between his hands. The execution of the relief for the net and the seven waterfowl swimming inside it was abandoned at a very early stage, with the outlines just roughly incised and with the square gridlines still preserved. On the other hand, the figures of the men are all complete and carved well. A vertical line of text to the right of the signalman and perhaps representing his shout says: *nḏr r wȝḏ* 'grasp strongly'. The action of the men is described in one horizontal line written above them: *rḏjt sḫt sḫt ȝpdw* [*jn wḥꜥ*][219]*w tp nfr n sḫt* 'closing the net, trapping the fowl [by the fowlers], the best of the marshland'. This is followed by the shout: *nḏr wȝḏ* 'grasp strongly', perhaps uttered by the last man in the line of haulers.

The extreme right side of the top two registers was probably occupied by a composite fishing and fowling scene, with the figures of the tomb owner in two papyrus boats facing one another and presumably separated by a papyrus thicket. Unfortunately, however, apart from portions of the tomb owner's legs and the boats, the scene has disappeared together with this part of the wall. The head of a child with a side lock has been drawn between the legs of Wekhhotep, but obviously does not belong to the main scene.

The bottom and continuous register first shows five offering bearers carrying food items on their shoulders or on trays supported on their shoulders. The first man brings two trays of trussed birds, the second the haunch of an ungulate, the third and fourth carry different cuts of meat, including the head of an ox, and the last man brings two trays overflowing with plucked and dressed fowl. Following are seven workmen engaged in harvesting and transporting papyrus stalks. They are naked, except for a belt worn around the waist, and all are clearly uncircumcised. They are of rough, coarse physical appearance and many have receding hair, indicating their mature age. The scene appears as if progressing in a cinematic fashion from right to left. First, two men tie a bundle of the stalks together using all their power to pull the binding rope tight, with each pressing with one knee against the bundle to make it more compact. A man then places himself on his hands and knees in order to load one of the bundles onto his back, followed by another who has almost lifted himself up, and then two others walking with difficulty under their heavy loads, while the last one deposits his burden on to the ground. In general, this rarely attested scene shares many similarities with papyrus gathering activities depicted in the Fifth Dynasty tombs of Ti[220] and Kahay and Nefer at Saqqara.[221]

Five men can then be seen manufacturing a papyrus boat. Although they are depicted in different postures, they are all using their strength and exerting force to pull ropes and closely bind the papyrus stems together, making the boat watertight. This is indicated in the caption describing their action: *spt smḥj* 'caulking the canoe'.[222] Their

[219] See Murray, *Saqqara Mastabas* 1, pl. 11; Blackman, *Meir* 2, 13.

[220] Wild, *Ti* 2, pl. 110.

[221] Lashien, *Kahai*, 28-29, pls. 11 a, 81-82.

[222] Montet, *Vie privée*, 79.

efforts are overseen by a very elderly, semi-naked man with unusually bushy hair and a full beard, who leans on a walking stick with his right hand and grasps the prow of the canoe with his left, perhaps for stability. To the right is a representation of so-called fighting boatmen. Two canoes and ten men are involved, but the number of sailors belonging to each team seems uneven. Their interaction is very aggressive.[223] Neither of the teams is trying to stop the fight by propelling their boat away; on the contrary, the two teams are pushing their boats closer to each other. The men in the prows of each canoe have placed their punting poles under their armpits in order to tussle with their counterpart. Others are using their poles to attack their adversaries. One man has fallen overboard but is still hanging on to the body of the boat; however, one of his opponents is stabbing him in the neck with a punting pole, even though a crocodile is lurking just beneath him.[224] To the extreme right of the register is a small boat with a lone fisherman and his dog. Hoisting his hand net, the man seems to have caught only two fish – a clarias catfish and a mullet (*Mugil* sp.)[225] – which seems more realistic than the same activity depicted in the neighbouring tomb of Senbi, where the net is shown full of fish of different species.

PILLARS (Pls. 66-67, 93)

Only the northern pillar has survived to a sufficient height to show that it is decorated on its four faces, with each occupied by a standing figure of the tomb owner. The figures on the east and west faces are similar, both oriented to the south, holding a staff in one hand and a sceptre in the other, and wearing a shoulder-length wig, a collar, bracelets, and what appears to be a sports tunic. The figures on the north and south faces are also similar, both looking east towards the entrance holding only a staff, with short hair and wearing a sash, a short, projecting kilt, and a leopard skin, complete with its head, tail, and claws. No inscriptions are preserved.

STATUE RECESS (Pls.68-72, 94-96)

All the figures on the walls of this recess are executed in coloured relief, with the inscriptions in incised relief and painted blue. The undecorated areas, including the roof, are painted in red with darker spots to imitate granite, while the cavetto cornice is striped, irregularly alternating between blue, green, and red. The two jambs are each inscribed with two vertical lines of hieroglyphs, as follows:

South Jamb: (1) *ḥtp dj nswt Wsjr nb nḥḥ ḫntj ȝbdw nṯr ꜥȝ nb jmnt ḫȝ m t ḥnḳt kȝ ȝpdw n kȝ n jmȝḫjj ḥȝtj-ꜥ Wḥw-ḥtp(.w) mȝꜥ-ḫrw* (2) : *jrj-pꜥt ḥȝtj-ꜥ jmj-r ḥmw-nṯr n Ḥwt-ḥr nbt Ḳjs ḥrj-tp ꜥȝ n Nḏft rḫ nswt mȝꜥ mr.f ḥrp nbw ḥȝtj-ꜥ Snb.j sȝ Wḥw-ḥtp(.w) mȝꜥ-ḫrw* '(1) an

[223] For an extensive discussion of this motif see Bolshakov, *BSEG* 17 (1993), 29-39.

[224] In a similar incident represented in the Sixth Dynasty tomb of Niankhpepy at Zawiyet el-Maiyitin, a crocodile is shown biting the leg of the man in the water (Varille, *Ni-ankh-Pepi*, pl. 6), while in the Twelfth Dynasty tomb of Khnumhotep II at Beni Hassan, the fallen boatman is depicted as having lost the lower part of his leg (Kanawati and Evans, *Beni Hassan* 1, pls. 75, 79, 135).

[225] Gamer-Wallert, *Fische und Fischkulte,* 14; Brewer and Friedman, *Fish and Fishing*, 72-73.

offering which the king gives and Osiris, lord of eternity, foremost of Abydos, and the great god, lord of the west (give), a thousand of bread, beer, oxen and fowl for the ka of the honoured one, the count, Wekhhotep, the justified, (2) the hereditary prince, the count, the overseer of priests of Hathor, lady of Qusiya, the great overlord of the UE 14, the true acquaintance of the king, whom he loves, the controller of gold, the count, Wekhhotep, son of Senbi, the justified'.

North Jamb: (1) *ḥtp dj nswt Jnpw sḫm tȝwj tpj ḏw.f ḥȝ m t ḥnḳt kȝ ȝpdw šs mnḫt dd pt ḳmȝt tȝ rnpjj(t) nbt ḫt nbt nfrt ꜥnḫt nṯr jm n kȝ n Wḫw-ḥtp(.w) mȝꜥ-ḫrw (2) jrj-pꜥt ḥȝtj-ꜥ ḥtmtj-bjtj smr wꜥtj mḥ-jb n nswt …ꜥn …f rḫt.f ḥȝtj-ꜥ Snb.j sȝ Wḫw-ḥtp(.w) mȝꜥ-ḫrw* '(1) an offering which the king gives and Anubis, the mighty one of the two lands, who is on his hill (gives), a thousand of bread, beer, oxen, fowl, alabaster and clothing, that which heaven gives and earth produces, all fresh things and all good things upon which a god lives, for the ka of Wekhhotep, the justified, (2) the hereditary prince, the count, the sealer of the king of Lower Egypt, the sole companion, the confidant of the king…, the pleasant one … who…of his knowledge, the count, Wekhhotep, son of Senbi, the justified'.

South Jamb Thickness: This area is divided into three registers, each depicting one offering bearer carrying food items, who face the tomb owner and his wife represented on the south wall of the recess. All of the men have short hair and wear short, tight kilts. The man in the top register carries the foreleg of an ungulate, with the accompanying text saying: *jms n kȝ n Wḫw-ḥtp(.w) mȝꜥ-ḫrw* 'presenting to the ka of Wekhhotep, the justified'. The bearer in the second register supports two trays of bread on his shoulders with the inscription above him reading: *jms n ḥȝtj-ꜥ Wḫw-ḥtp(.w) mȝꜥ-ḫrw* 'presenting to the count, Wekhhotep, the justified'. The offering bearer in the bottom register also supports two trays on his shoulders, one laden with fowl and the other with cuts of meat. The accompanying label is identical to that in the top register.

North Jamb Thickness: Like its southern counterpart, the north thickness is divided into three registers, each showing an offering bearer. The man in the top register supports two trays containing cuts of meat, including the heads of two oxen, on his shoulders. Above him is written: *jms n Wḫw-ḥtp(.w) mȝꜥ-ḫrw* 'presenting to Wekhhotep, the justified'. In the middle register, the bearer carries the foreleg of a large ungulate, with the accompanying text saying: *jms n kȝ n ḥȝtj-ꜥ Wḫw-ḥtp(.w) mȝꜥ-ḫrw* 'presenting to the ka of the count, Wekhhotep, the justified'. The last man is wringing the neck of a goose and above him is written: *jnw nfrw n(w) Sḫt n ḥȝtj-ꜥ Wḫw-ḥtp(.w) mȝꜥ-ḫrw* 'the good gifts of marshes for the count, Wekhhotep, the justified'.

South Wall of Recess: Facing outwards, the tomb owner and his wife are depicted in equal size. Wekhhotep wears a shoulder-length wig, a collar, bracelets, and a short, pleated, projecting kilt, holding a staff in one hand and a sceptre in the other. His wife wears a long wig, a collar, bracelets, anklets, and a long, tight dress with shoulder straps while placing her right hand on his right shoulder. The inscription above them reads: *ḥtp dj nswt Wsjr ḥȝ m t ḥnḳt kȝ ȝpdw šs mnḫt n ḥȝtj-ꜥ Wḫw-ḥtp(.w) ḥmt …* 'an offering which the king gives and Osiris (gives), a thousand of bread, beer, oxen, fowl, alabaster and clothing for the count, Wekhhotep; [his] wife …'

North Wall of Recess: This wall is identical to the representations on the opposite wall, except that here the wife places her left hand on Wekhhotep's left shoulder. In the inscription above the couple, he is described as *mꜣꜥ-ḫrw* 'the justified', and she as *ḥmt.f …ḥtp* 'his wife, [Djehuti]hotep.

West Wall of Recess: The wall is divided into two registers, in the upper one of which the tomb owner appears before an offering table. Wearing a shoulder-length wig, a collar, and a short, tight kilt, Wekhhotep sits on a chair with a low, cushioned back and lion's legs and holds a folded cloth in his left hand while extending his right hand towards an offering table laden with nineteen half-loaves of bread/reed leaves. Above the table are various cuts of meat, including the foreleg and head of an ox, ribs, a goose, and an unidentified green vegetable. The inscription above the scene reads: *ḥtp dj nswt Jnpw ḫꜣ m t ḥnḳt kꜣ ꜣpdw šs mnḫt ḫr Wsjr ḥꜣtj-ꜥ Wḫw-ḥtp(.w)* 'an offering which the king gives and Anubis (gives), a thousand of bread, beer, oxen, fowl, alabaster and clothing, before Osiris, the count, Wekhhotep. The bottom register shows a man binding an ox in preparation for slaughter. The enraged animal appears to struggle and call out, causing the man to pull strongly on the rope. Above the scene is written: *mꜣꜥw n jmꜣḫjj Wḫw-ḥtp(.w) mꜣꜥ-ḫrw* 'offerings for the honoured one, Wekhhotep, the justified'.

INDEX

DEITIES

KINGS

INDIVIDUALS

TITLES

PLATES

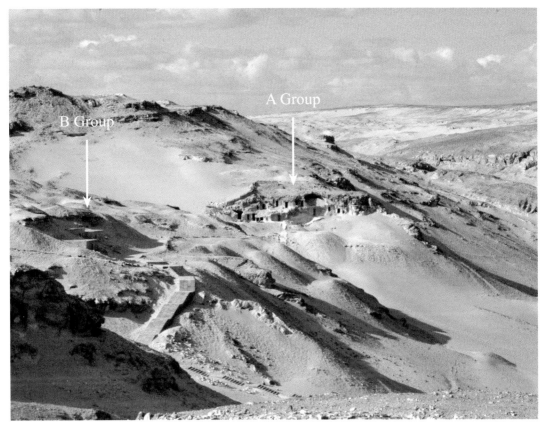

(a) Northeastern section of the cemetery

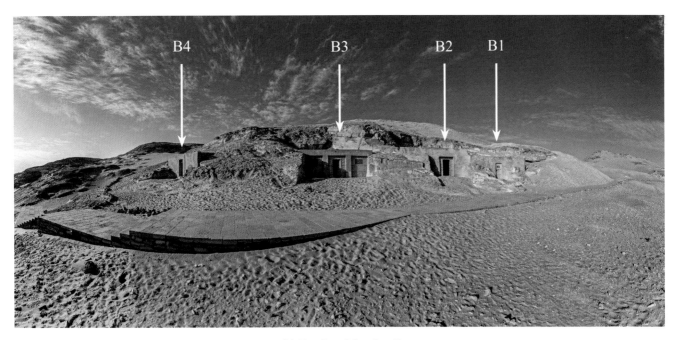

(b) Tombs of Section B

Pl. 1. General views

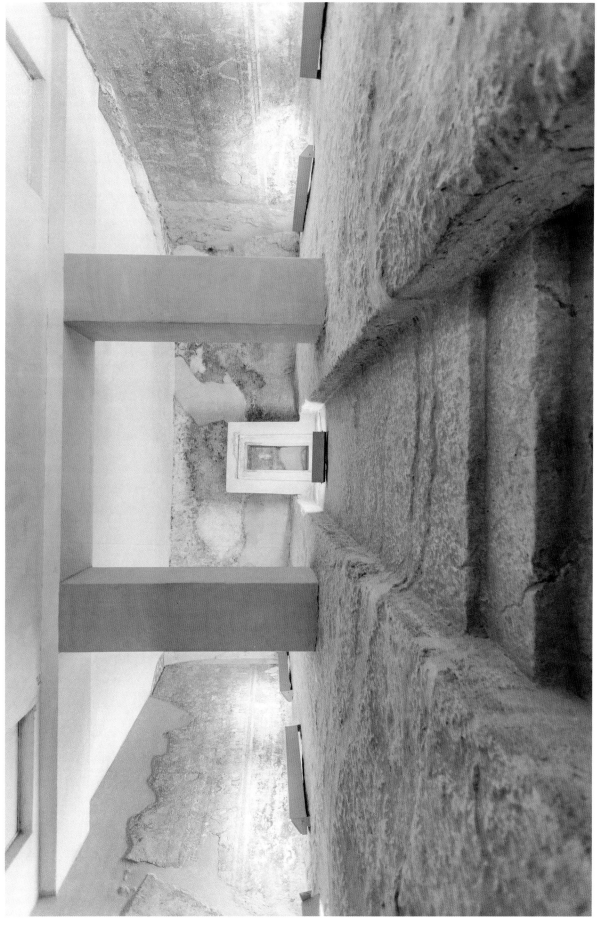

Looking west

Pl. 2. B1, general view

(a) Detail

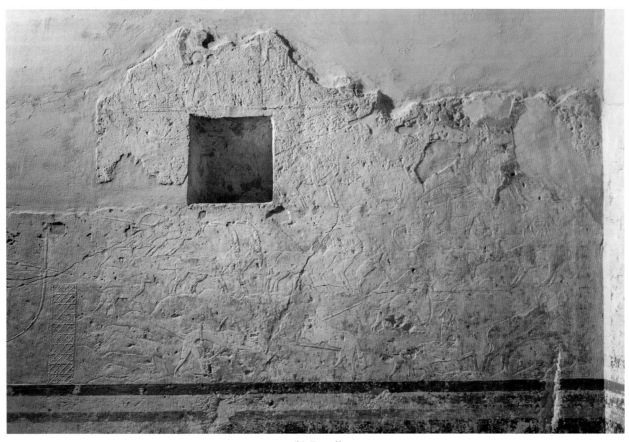

(b) Detail

Pl. 3. B1, east wall, south of entrance (see pl. 75)

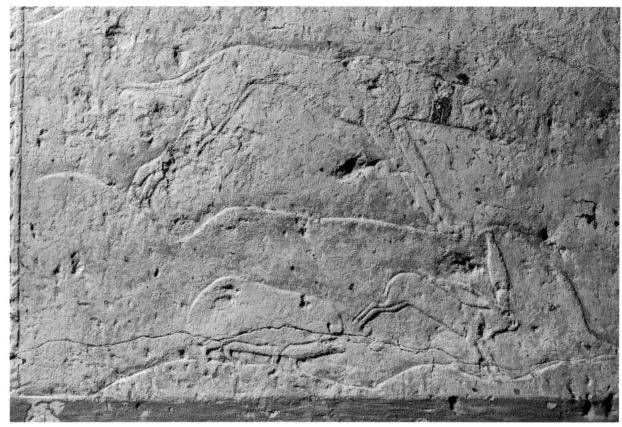

(a) Detail

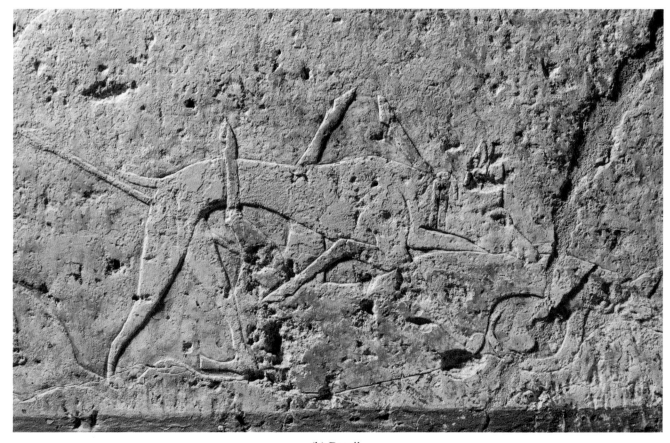

(b) Detail

Pl. 4. B1, east wall, south of entrance (see pl. 75)

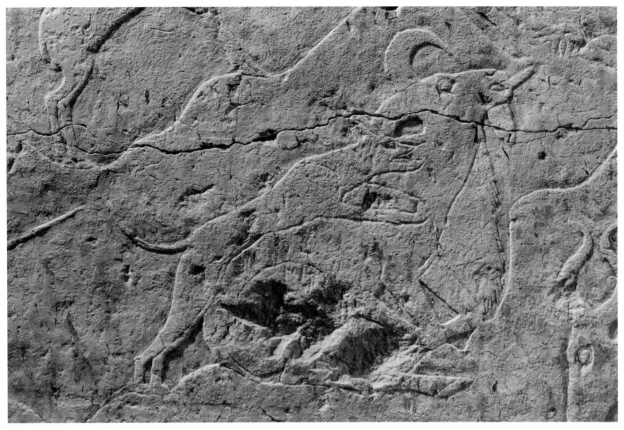

(a) Detail

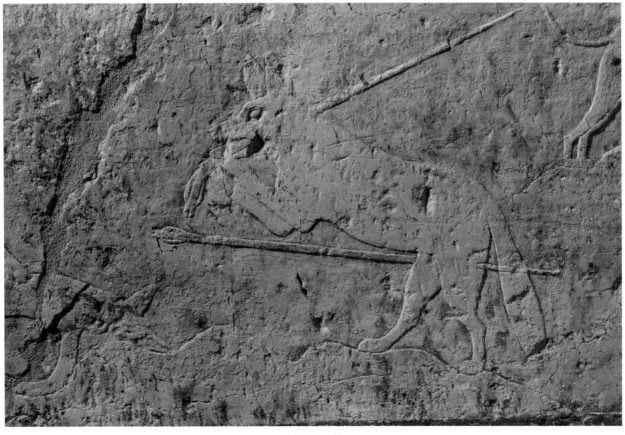

(b) Detail

Pl. 5. B1, east wall, south of entrance (see pl. 75)

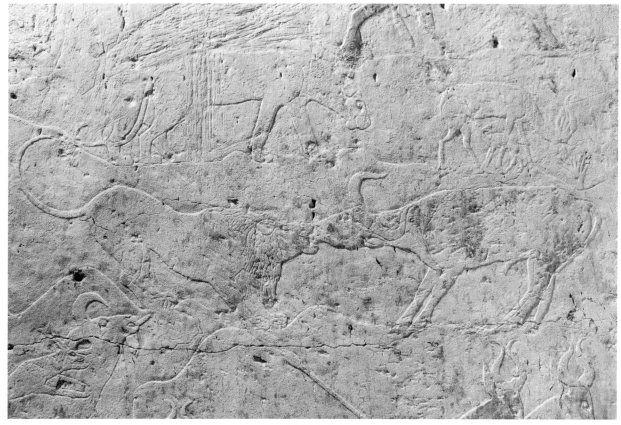

(a) Detail

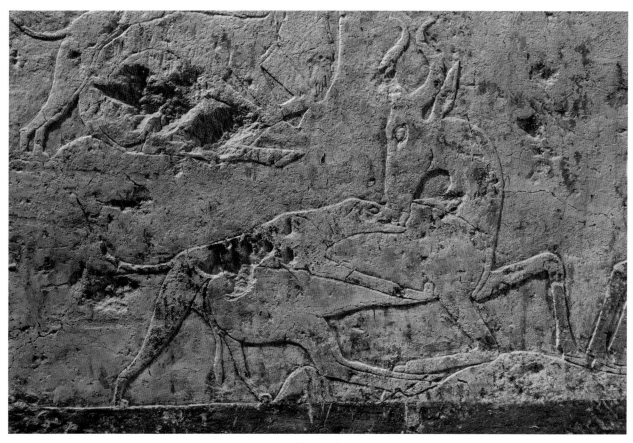

(b) Detail

Pl. 6. B1, east wall, south of entrance (see pl. 75)

(a) South wall (see pls. 76-77)

(b) North wall (see pls. 78-80)

Pl. 7. B1

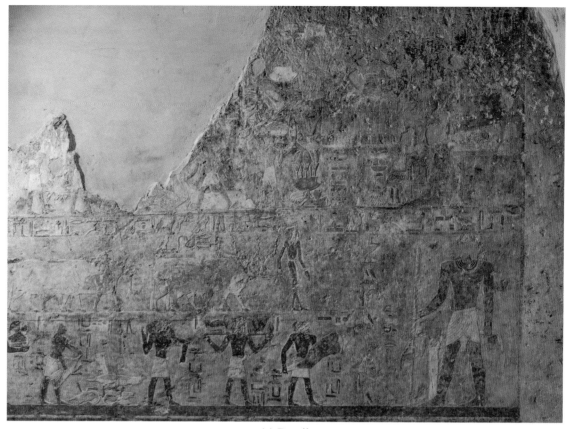

(a) Detail

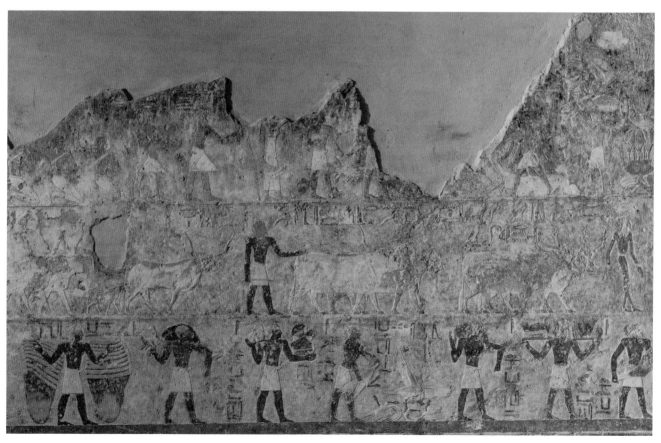

(b) Detail

Pl. 8. B1, south wall, west section (see pl. 77)

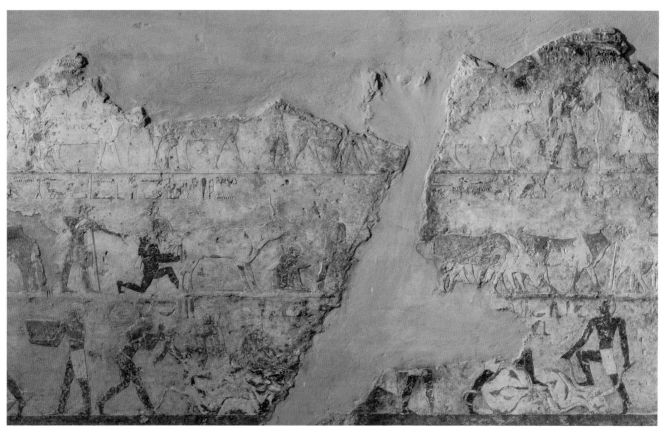

(a) Centre, detail (see pls. 76-77)

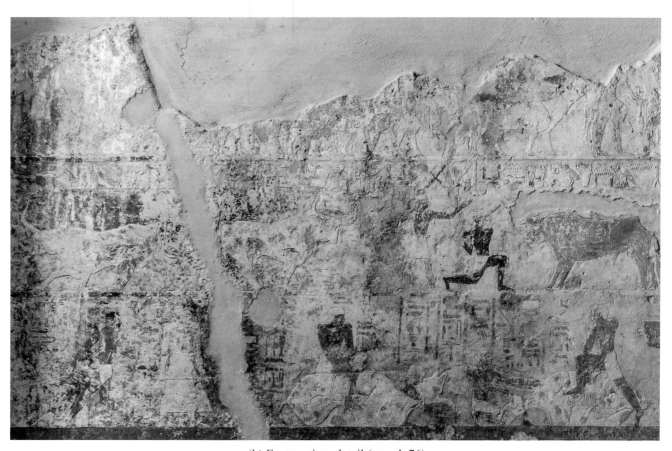

(b) East section, detail (see pl. 76)

Pl. 9. B1, south wall

(a) East section, detail (see pl. 76)

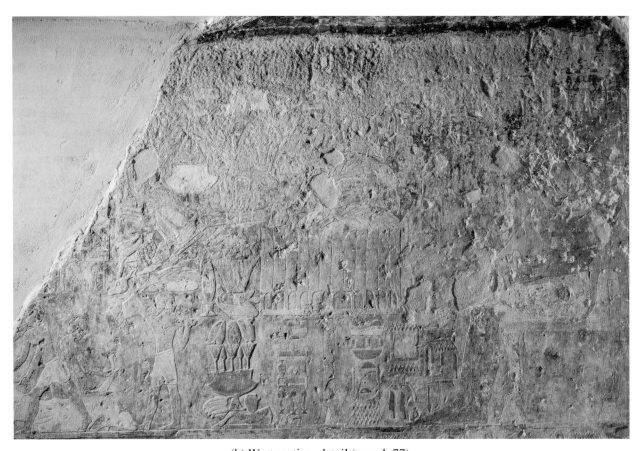

(b) West section, detail (see pl. 77)

Pl. 10. B1, south wall

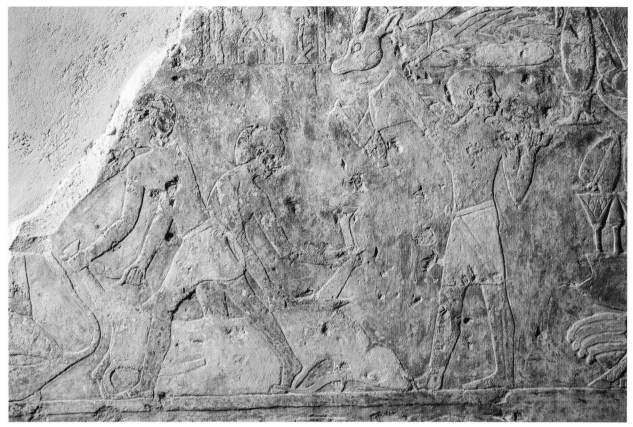

(a) Detail

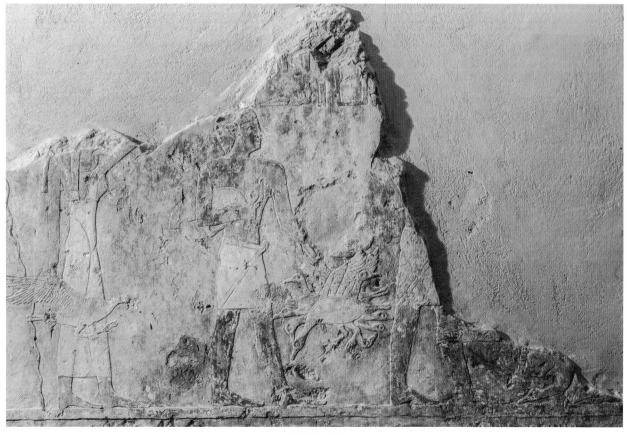

(b) Detail

Pl. 11. B1, south wall, west section (see pl. 77)

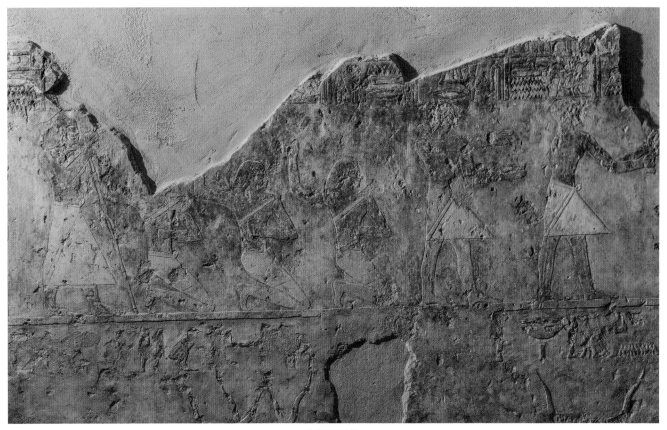

(a) Detail

(b) Detail

Pl. 12. B1, south wall, west section (see pl. 77)

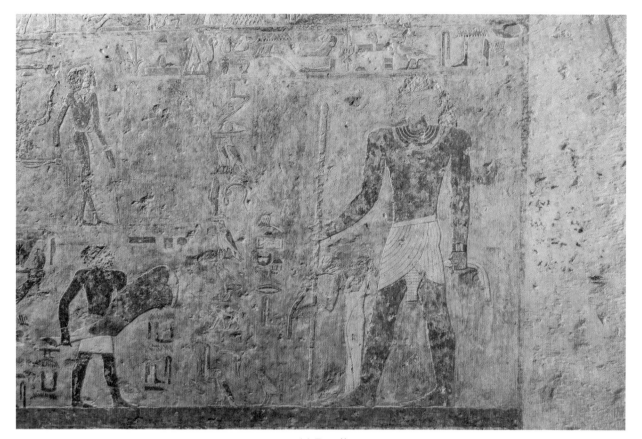

(a) Detail

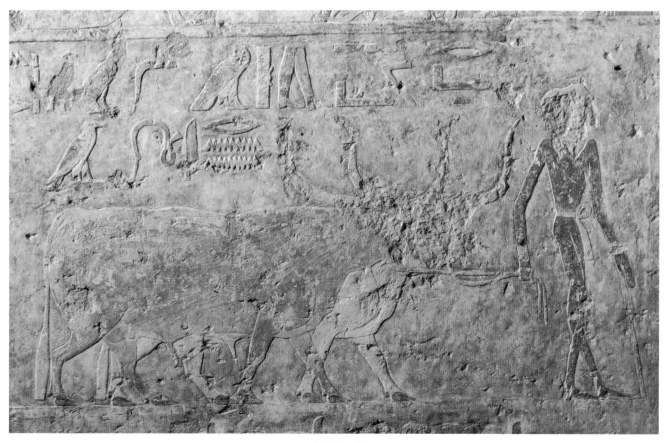

(b) Detail

Pl. 13.　B1, south wall, west section (see pl. 77)

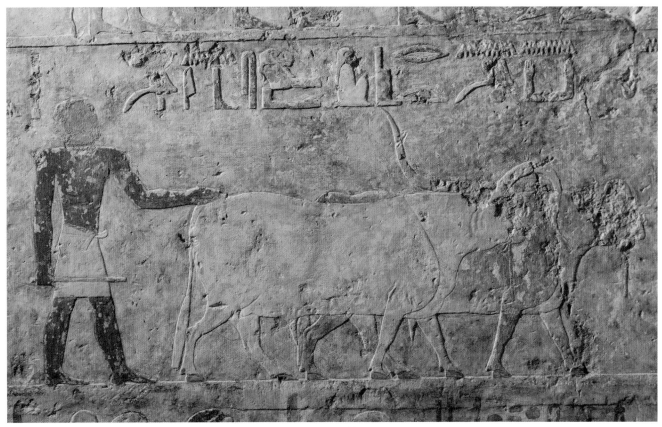

(a) Detail

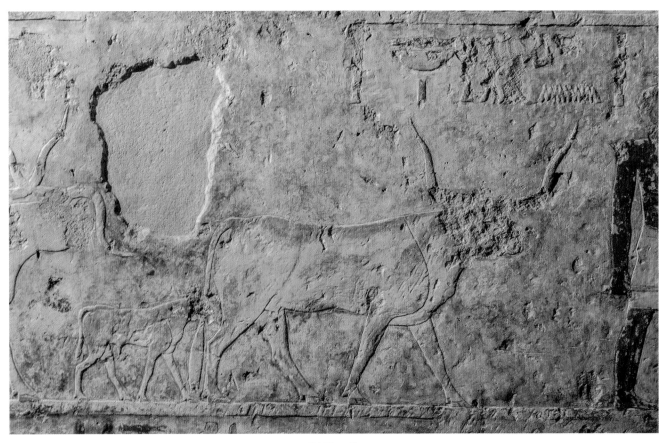

(b) Detail

Pl. 14. B1, south wall, west section (see pl. 77)

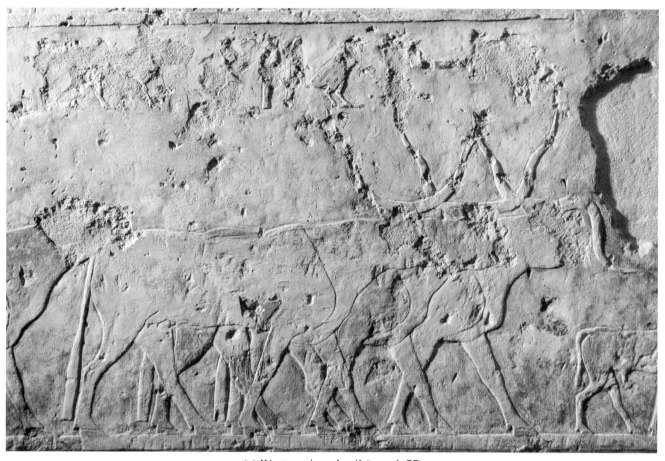

(a) West section, detail (see pl. 77)

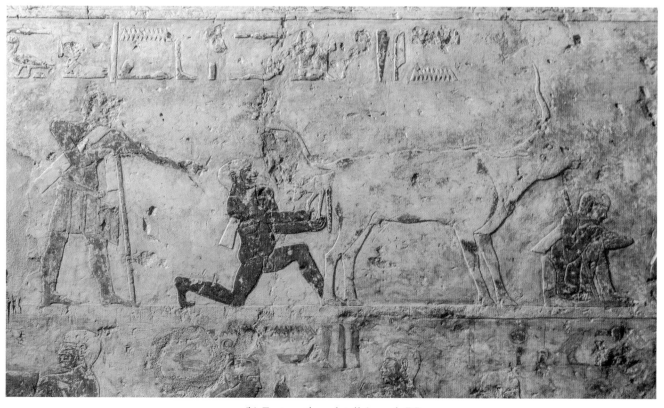

(b) East section, detail (see pl. 76)

Pl. 15. B1, south wall

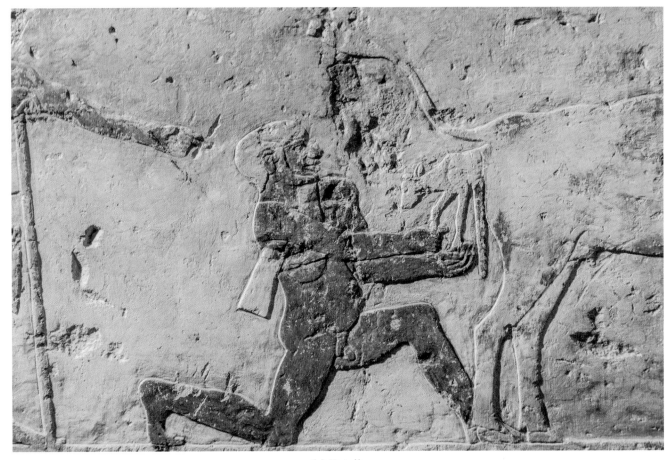

(a) Detail

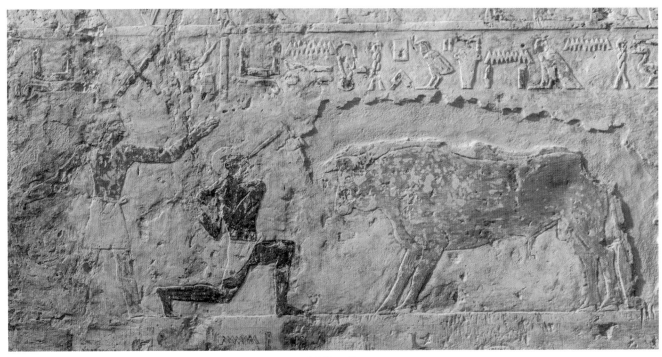

(b) Detail

Pl. 16. B1, south wall, east section (see pl. 76)

(a) East section, detail (see pl. 76)

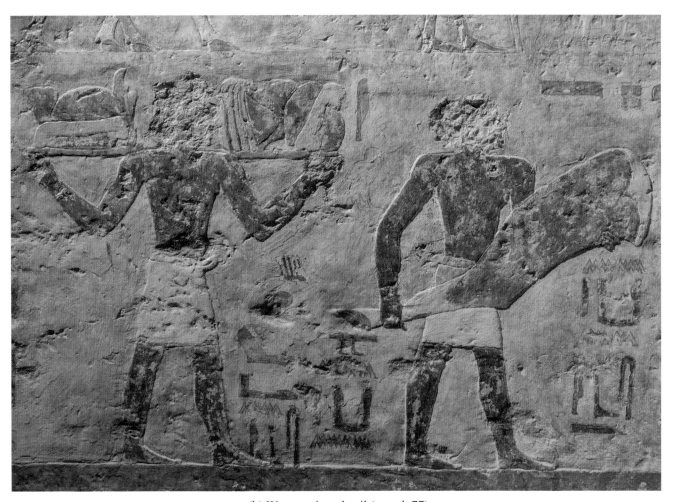

(b) West section, detail (see pl. 77)

Pl. 17. B1, south wall

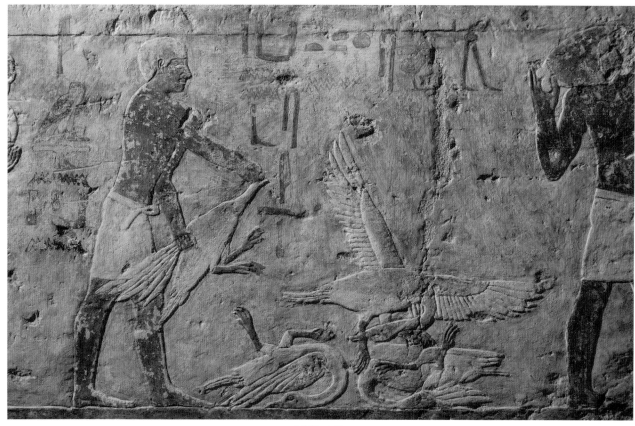

(a) Detail

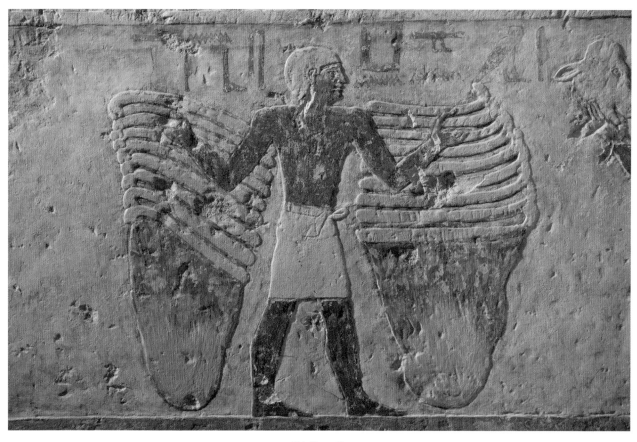

(b) Detail

Pl. 18. B1, south wall, west section (see pl. 77)

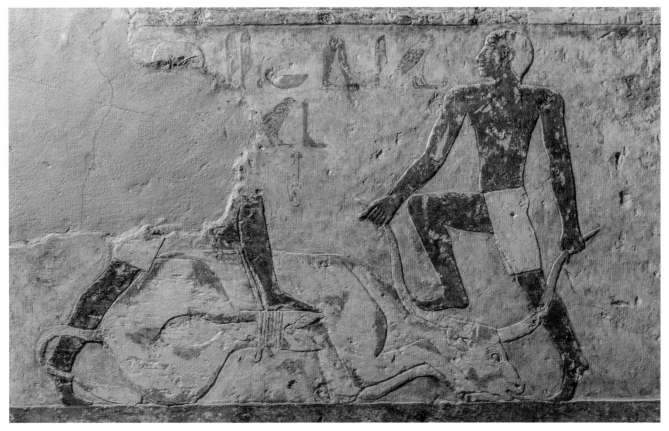

(a) West section, detail (see pl. 77)

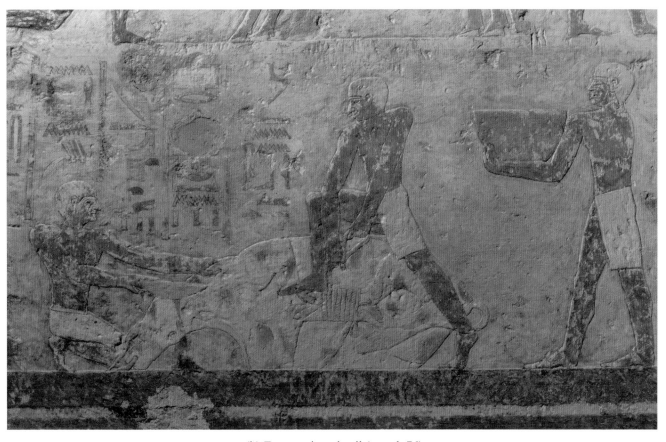

(b) East section, detail (see pl. 76)

Pl. 19.　B1, south wall

Detail (see pl. 76)

Pl. 20. B1, south wall, east section

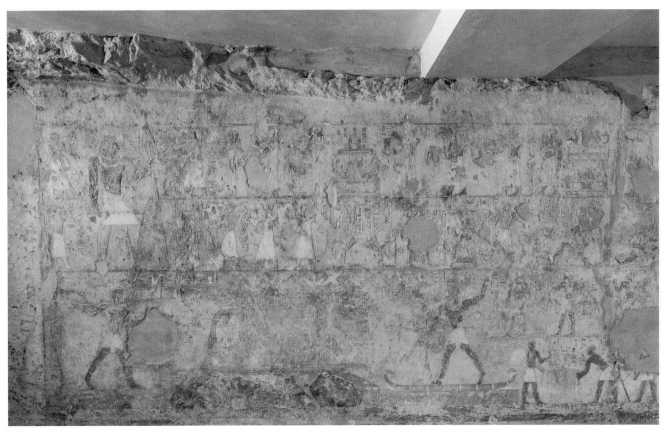

(a) West section (see pls. 78, 80)

(b) East section (see pl. 79)

Pl. 21. B1, north wall

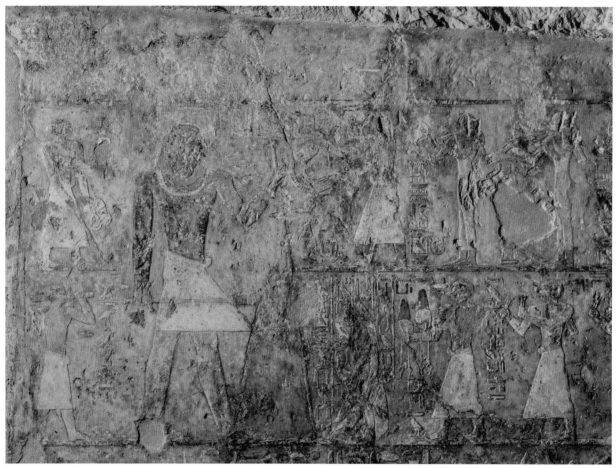

(a) Detail

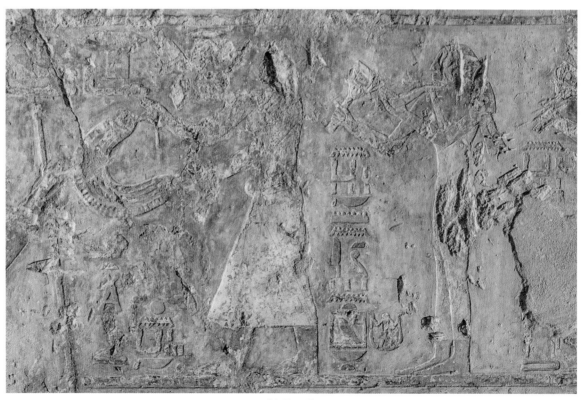

(b) Detail

Pl. 22. B1, north wall, west section (see pl. 78)

(a) West section, detail (see pl. 78)

(b) East section, detail (see pls. 78-79)

Pl. 23. B1, north wall

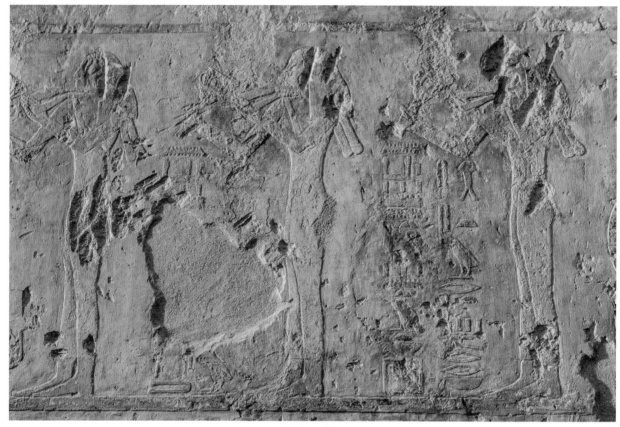

(a) Detail

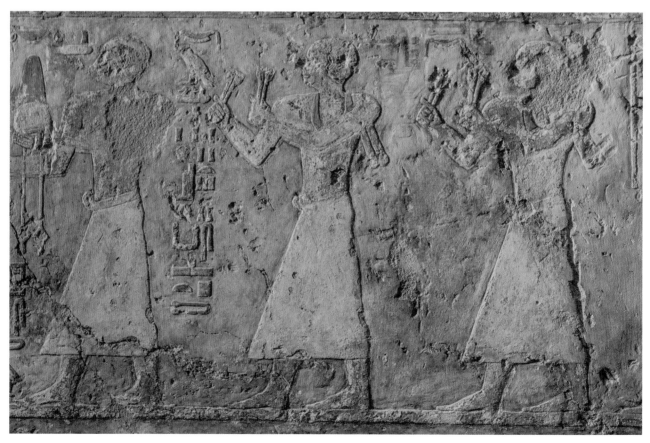

(b) Detail

Pl. 24. B1, north wall, west section (see pl. 78)

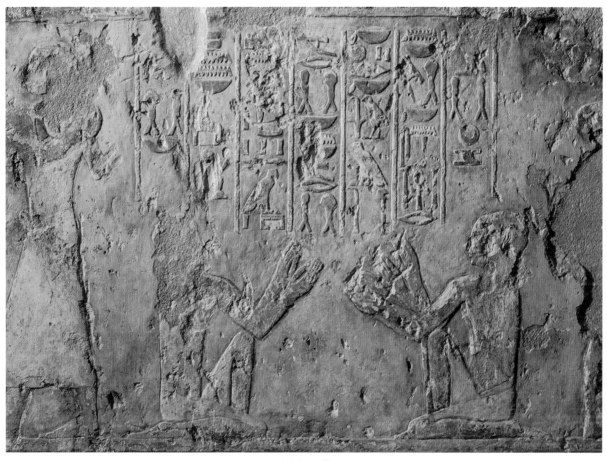

(a) Detail

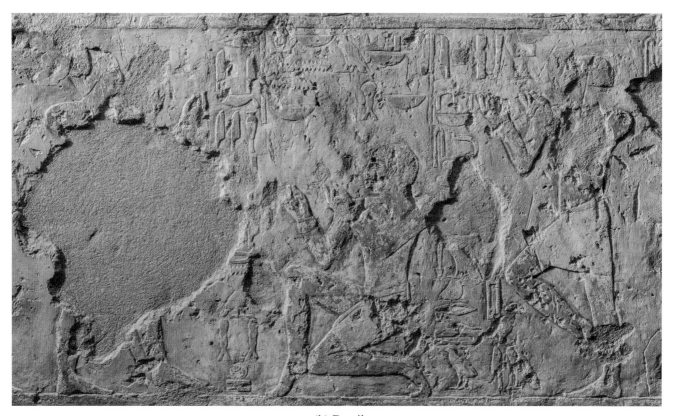

(b) Detail

Pl. 25. B1, north wall, west section (see pl. 78)

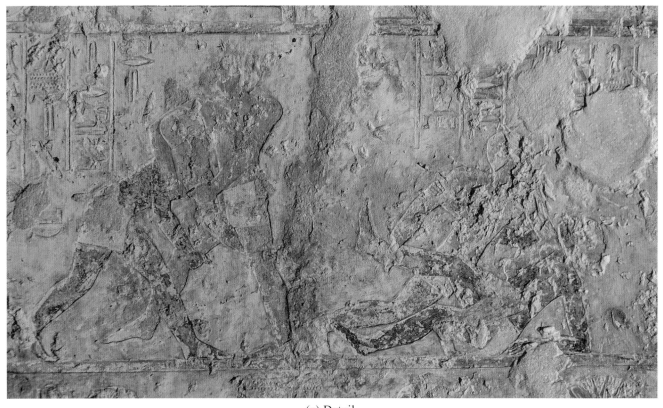

(a) Detail

(b) Detail

Pl. 26. B1, north wall, east section (see pls. 78-79)

Detail (see pls. 78, 80)

Pl. 27. B1, north wall, west section

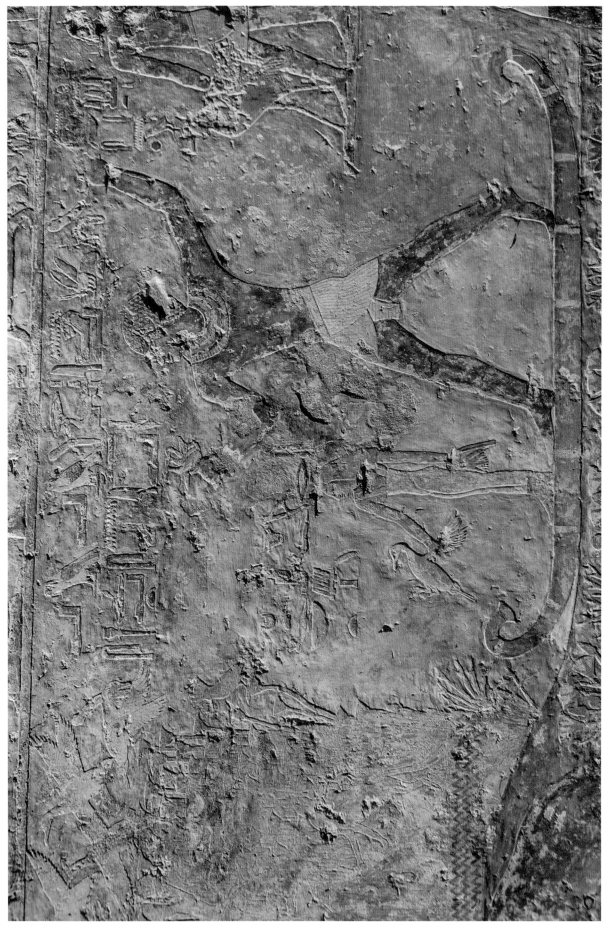

Detail (see pls. 78, 80)

Pl. 28. B1, north wall, west section

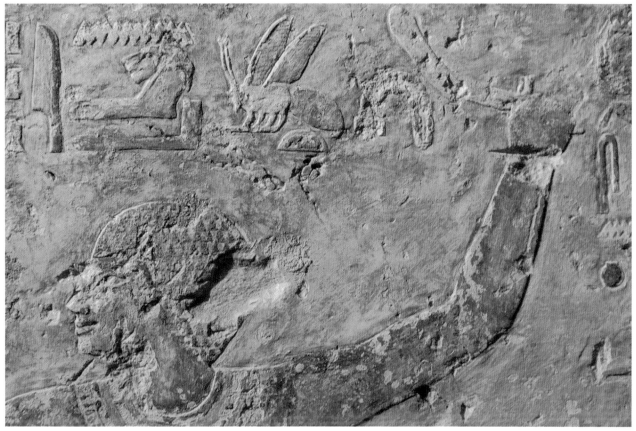

(a) Detail

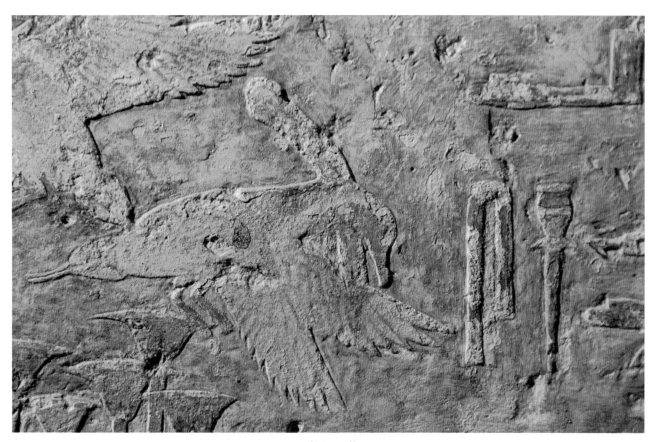

(b) Detail

Pl. 29. B1, north wall, west section (see pls. 78, 80)

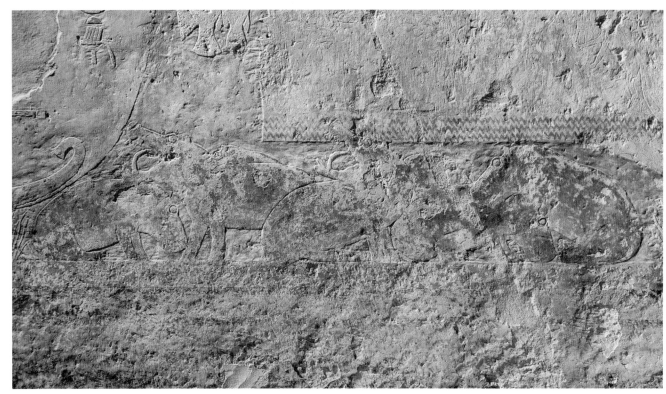

(a) Detail (see pls. 78, 80)

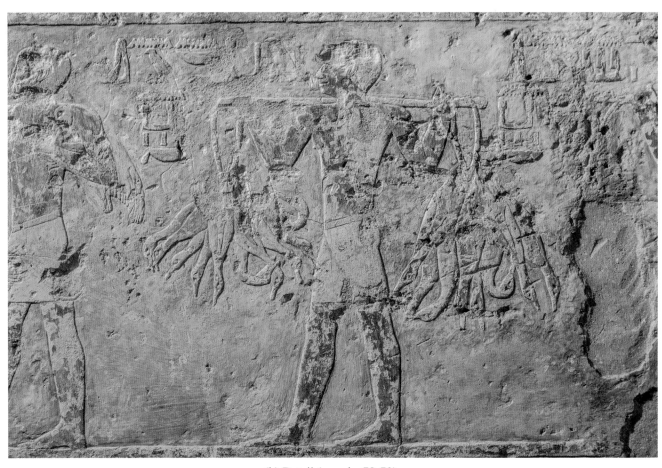

(b) Detail (see pls. 78-79)

Pl. 30. B1, north wall, west section

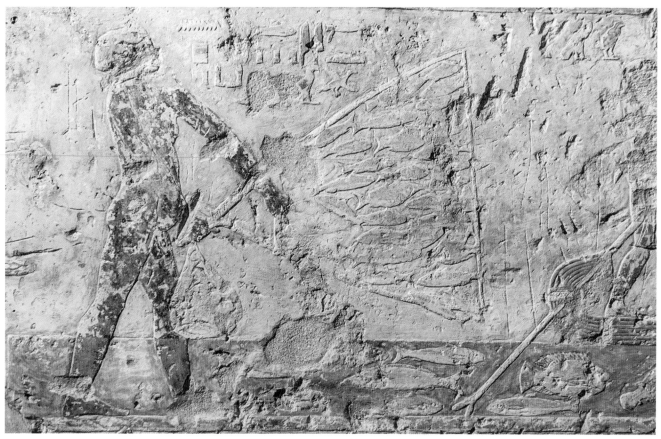

(a) Detail

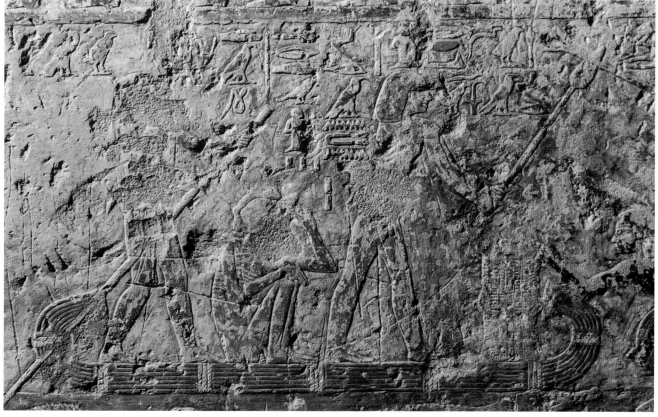

(b) Detail

Pl. 31. B1, north wall, east section (see pl. 79)

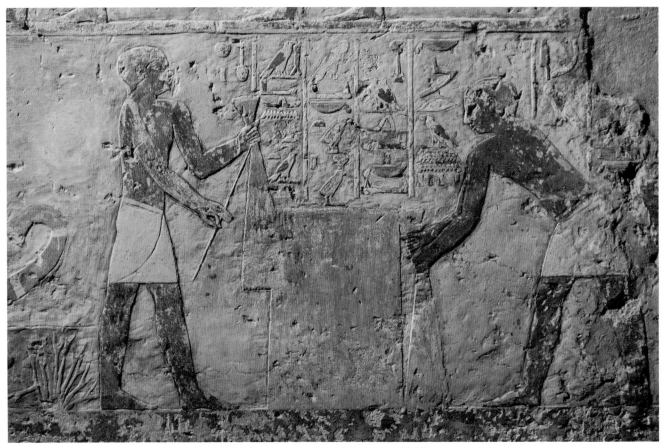

(a) West section, detail (see pls. 78-79)

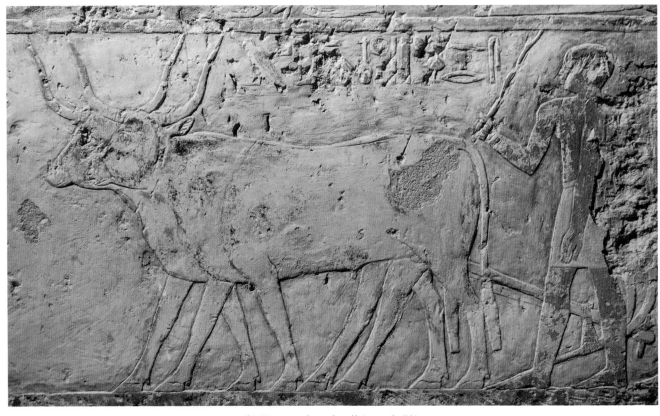

(b) East section, detail (see pl. 79)

Pl. 32. B1, north wall

Looking west

Pl. 33. B2, general view

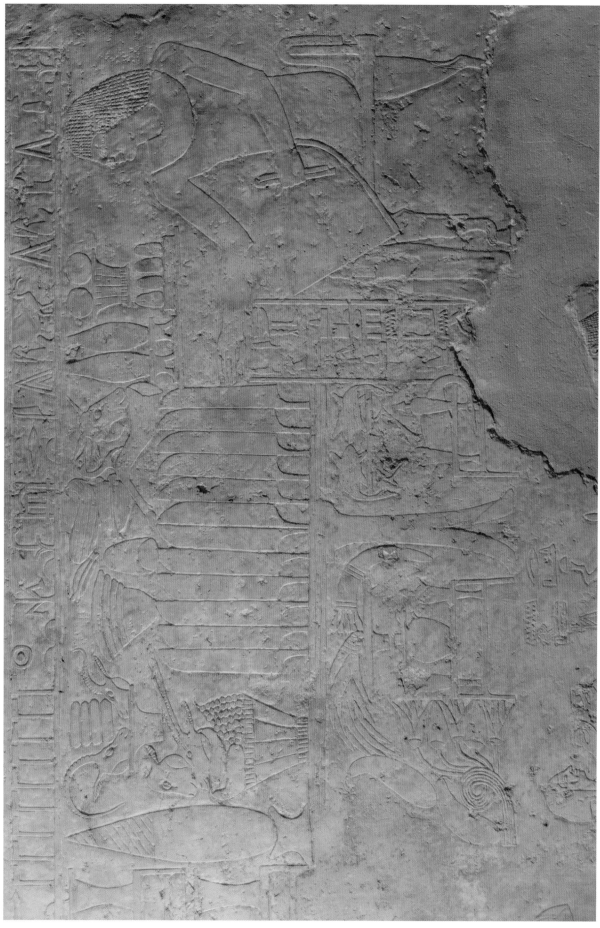

Detail (see pl. 86)

Pl. 34. B2, south wall, west section

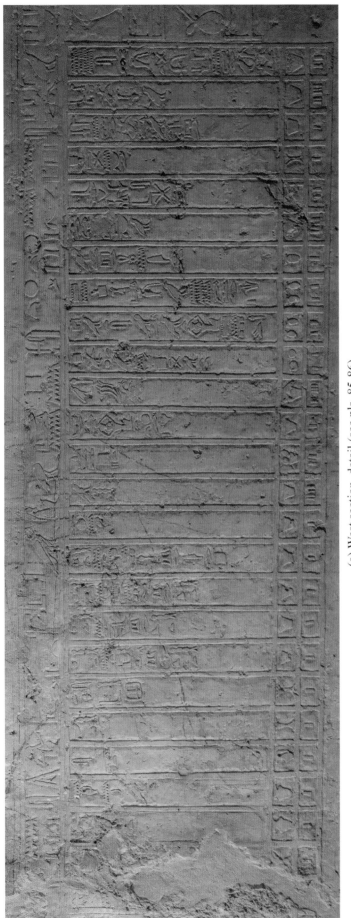

(a) West section, detail (see pls. 85-86)

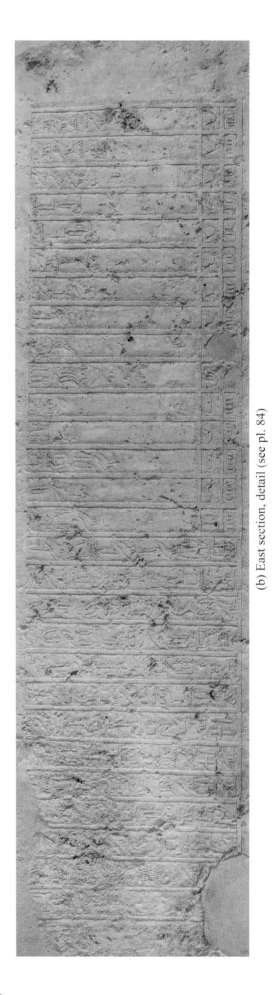

(b) East section, detail (see pl. 84)

Pl. 35. B2, south wall

(a) Centre, detail (see pls. 84-85)

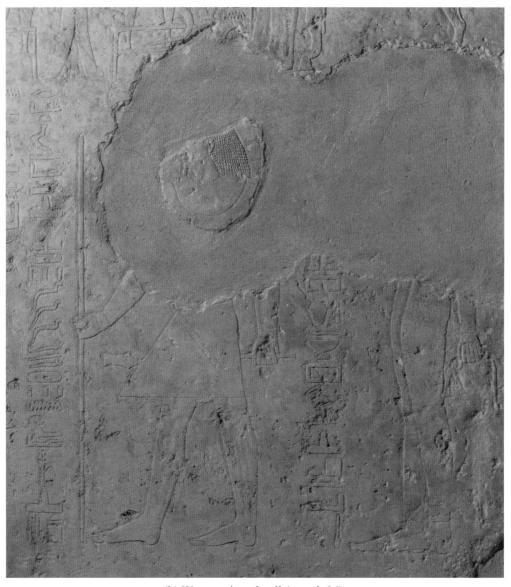

(b) West section, detail (see pl. 86)

Pl. 36. B2, south wall

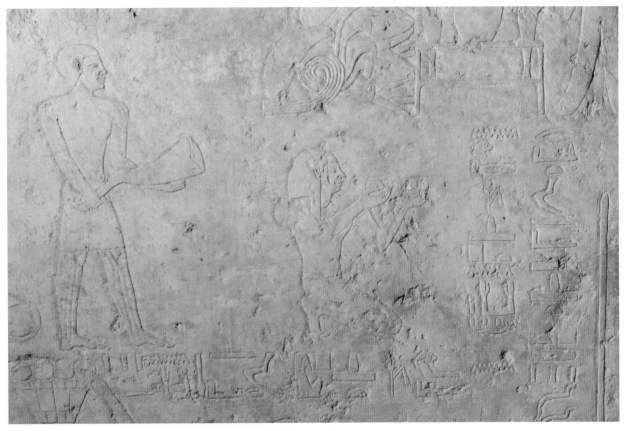

(a) Detail

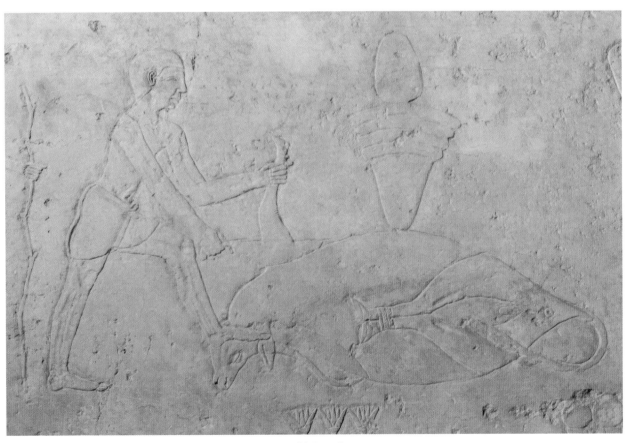

(b) Detail

Pl. 37. B2, south wall, west section (see pl. 86)

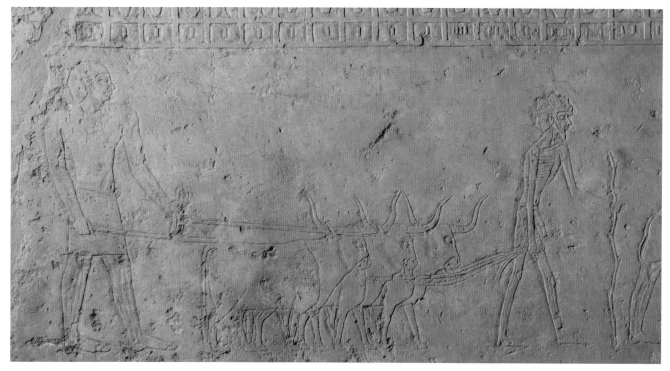

(a) Detail (see pls. 85-86)

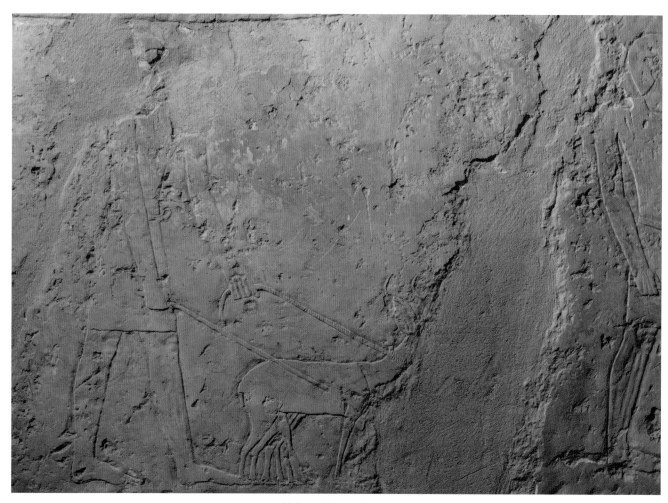

(b) Detail (see pl. 85)

Pl. 38. B2, south wall, west section

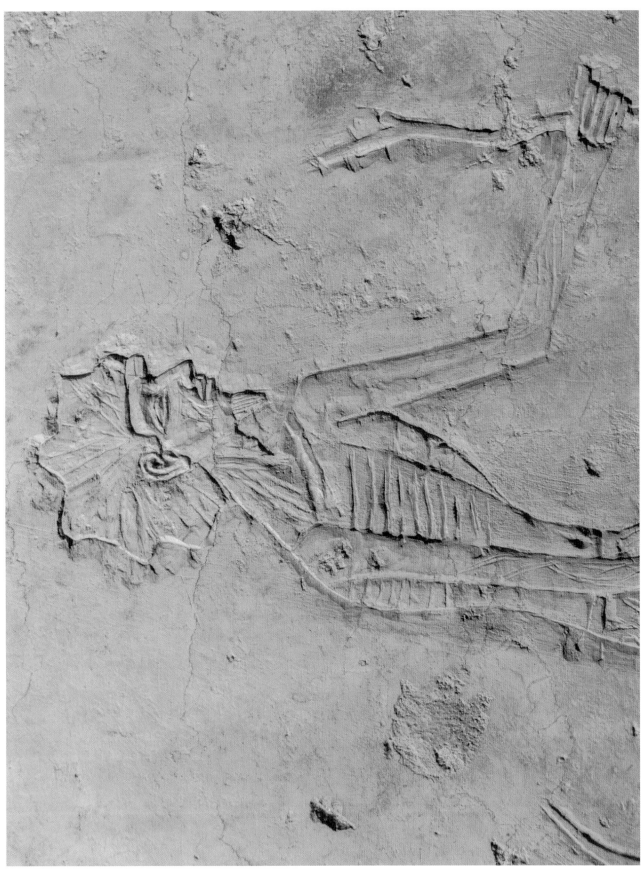

Detail (see pl. 86)

Pl. 39. B2, south wall, west section

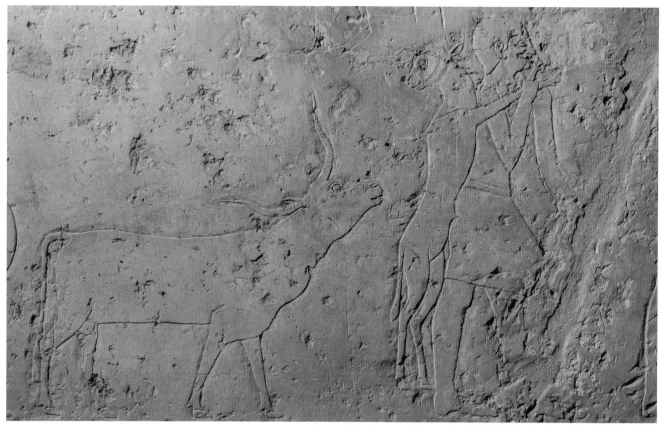

(a) Detail

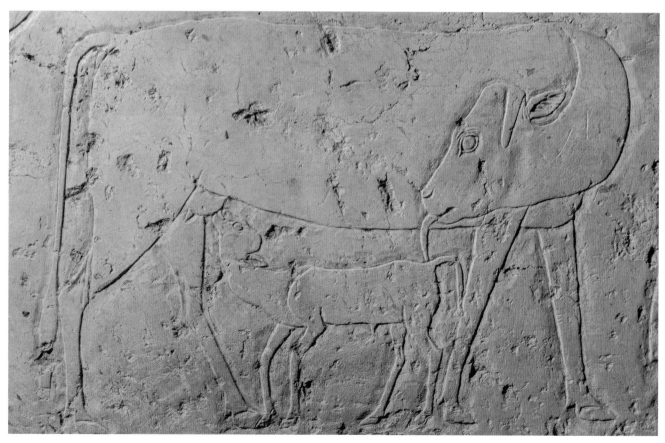

(b) Detail

Pl. 40. B2, south wall, centre (see pl. 85)

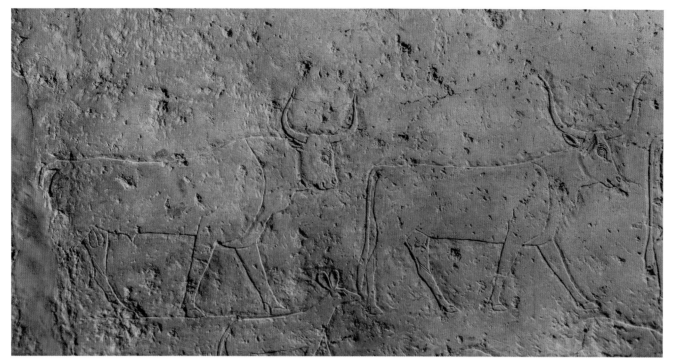

(a) Centre, detail (see pl. 85)

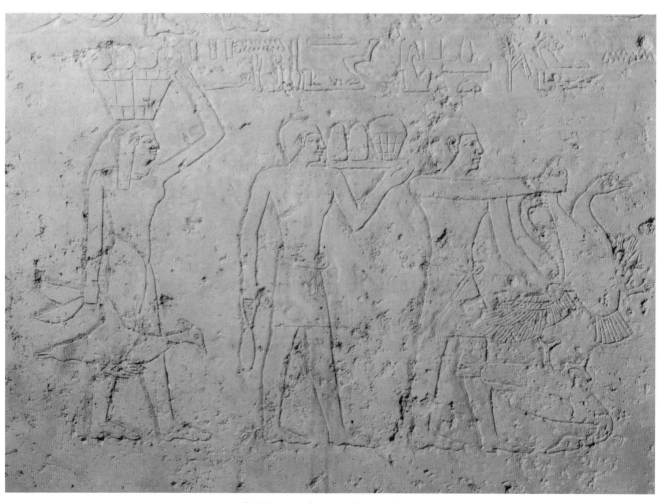

(b) West section, detail (see pl. 86)

Pl. 41. B2, south wall

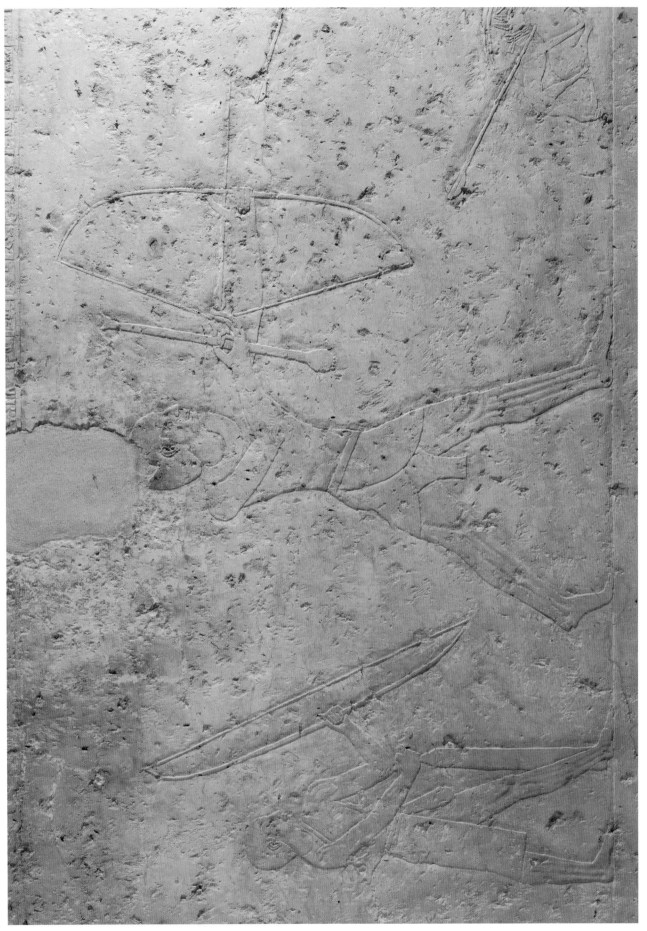

Detail (see pl. 84)

Pl. 42. B2, south wall, east section

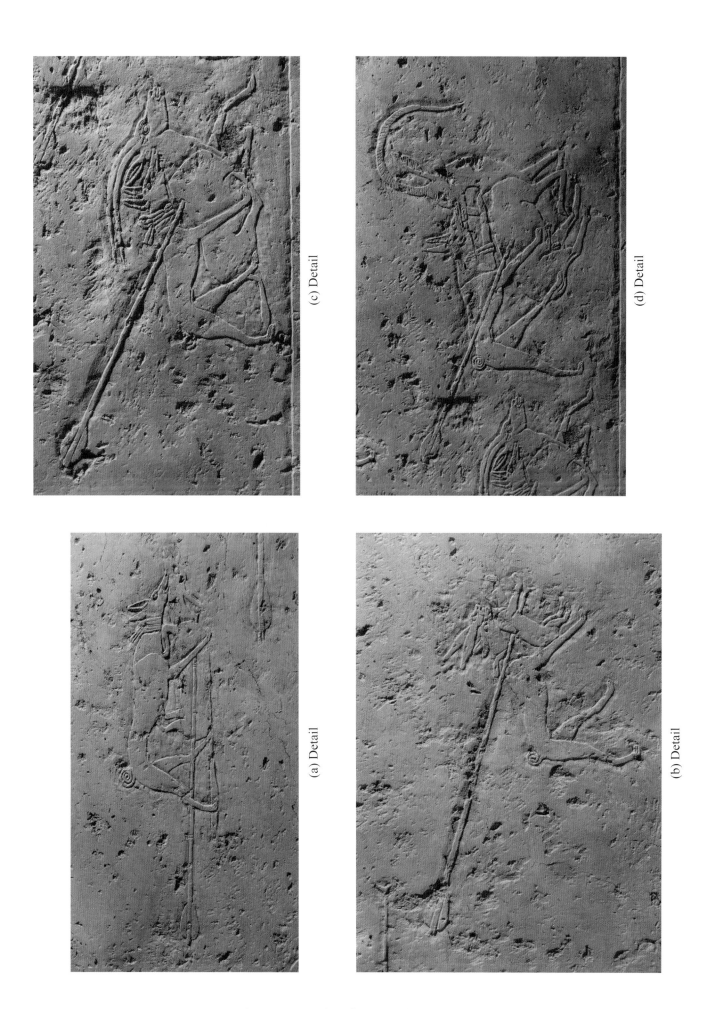

(c) Detail

(d) Detail

(a) Detail

(b) Detail

Pl. 43. B2, south wall, east section (see pl. 84)

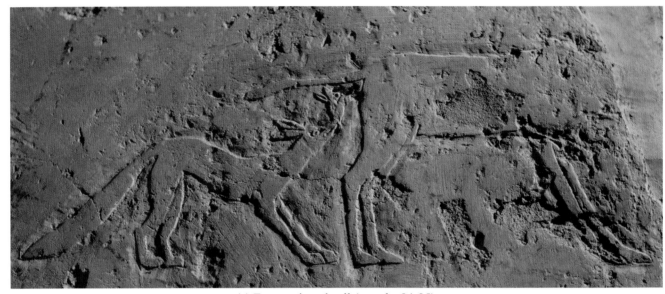

(a) East section, detail (see pls. 84-85)

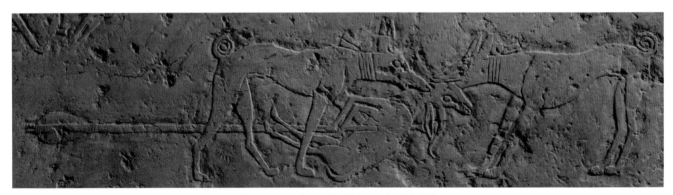

(b) East section, detail (see pls. 84-85)

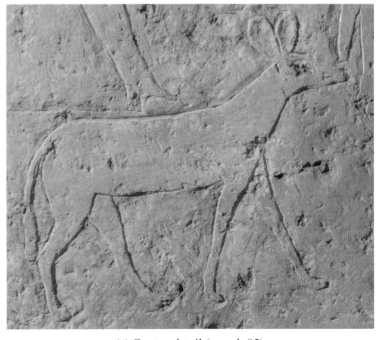

(c) Centre, detail (see pl. 85)

Pl. 44. B2, south wall

(a) Detail (see pl. 84)

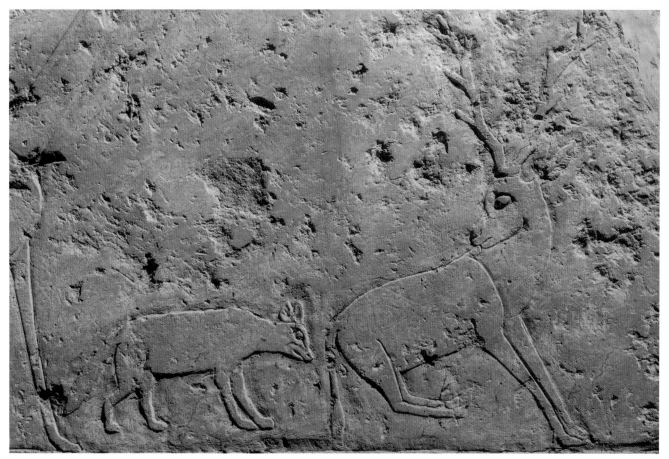

(b) Detail (see pls. 84-85)

Pl. 45. B2, south wall, east section

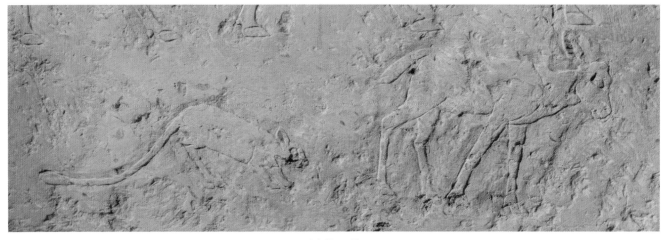

(a) Detail

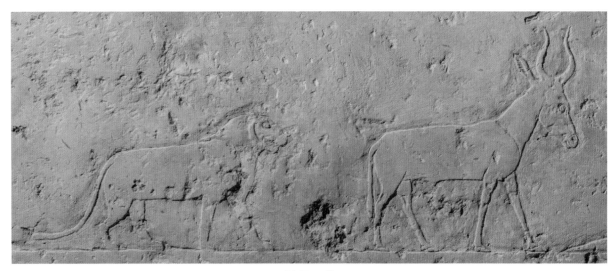

(b) Detail

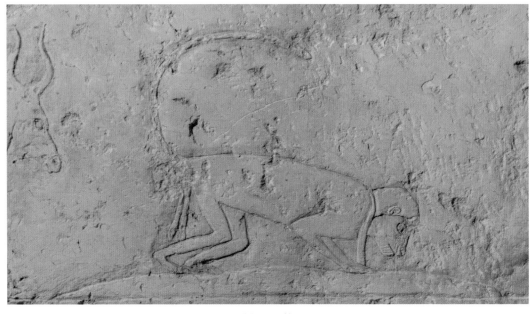

(c) Detail

Pl. 46. B2, south wall, centre (see pl. 85)

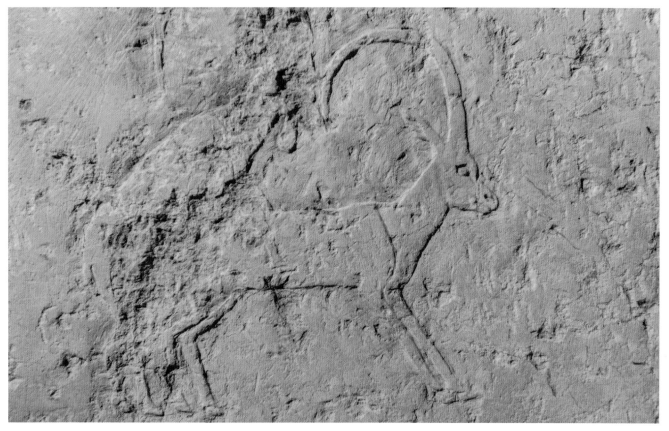

(a) Detail

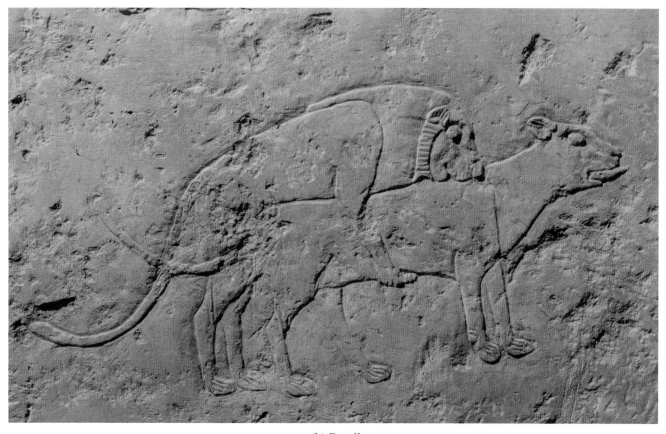

(b) Detail

Pl. 47. B2, south wall, centre (see pl. 85)

(a) Detail

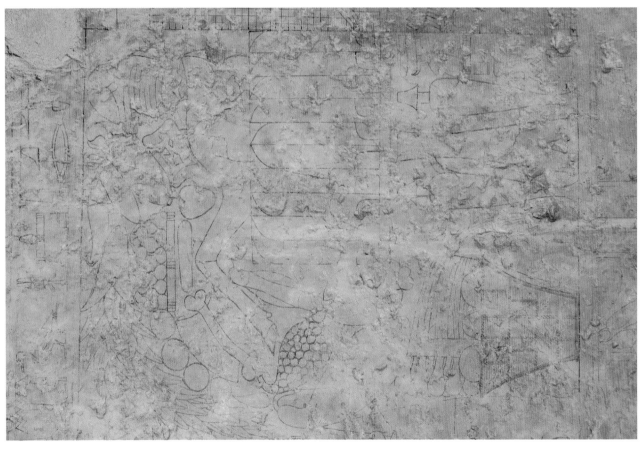

(b) Detail

Pl. 48. B2, west wall, north of statue recess (see pl. 87)

Pl. 49. B2, west wall, north of statue recess, detail (see pl. 87)

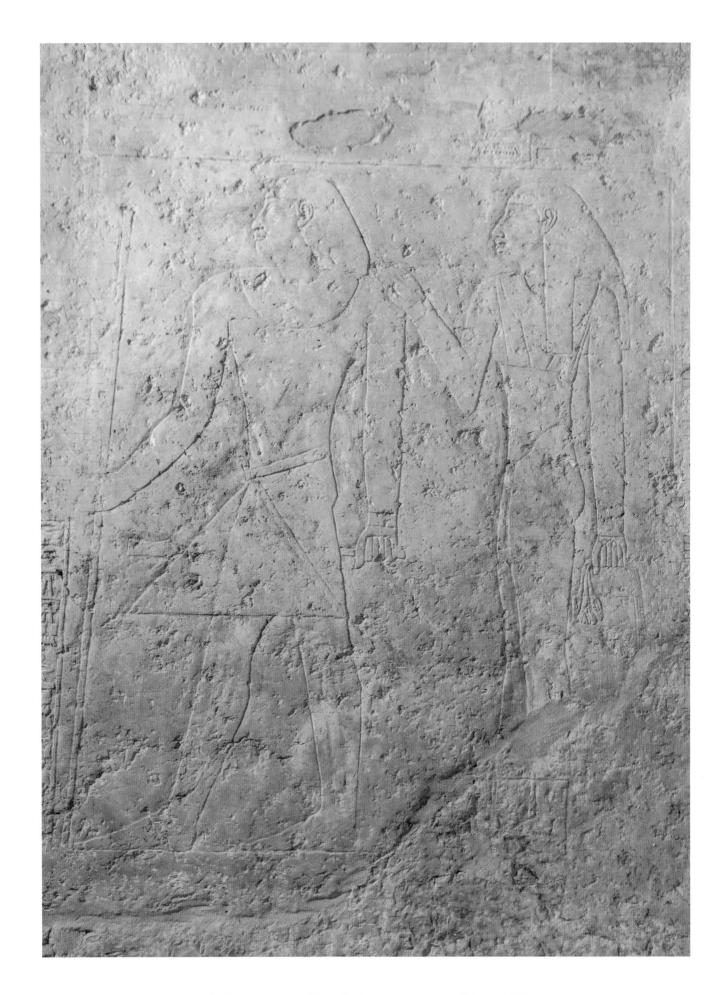

Pl. 50. B2, west wall, north of statue recess, detail (see pl. 87)

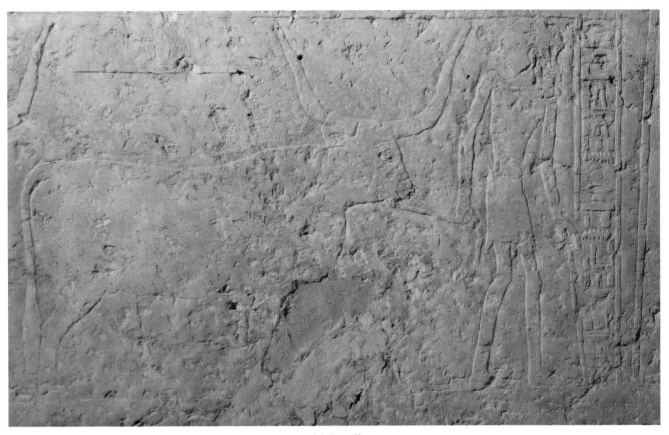

(a) Detail

(b) Detail

Pl. 51. B2, west wall, north of statue recess (see pl. 87)

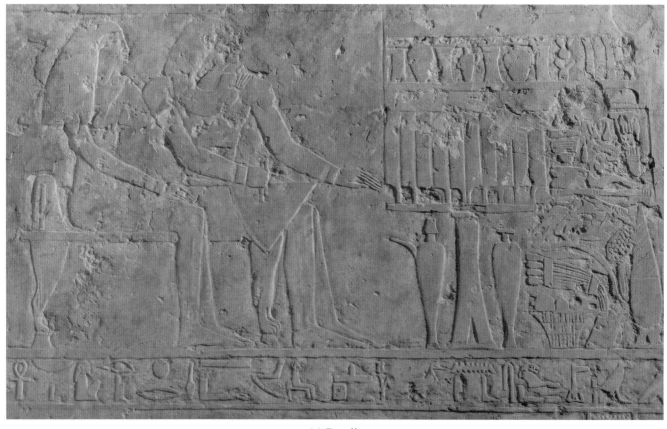

(a) Detail

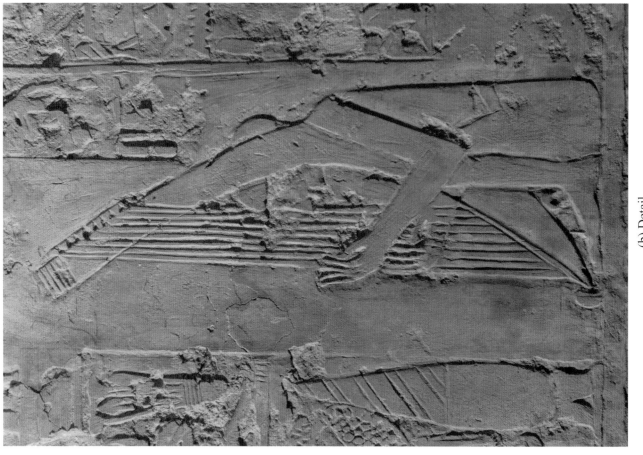
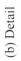

(b) Detail

Pl. 52. B2, west wall, south of statue recess (see pl. 88)

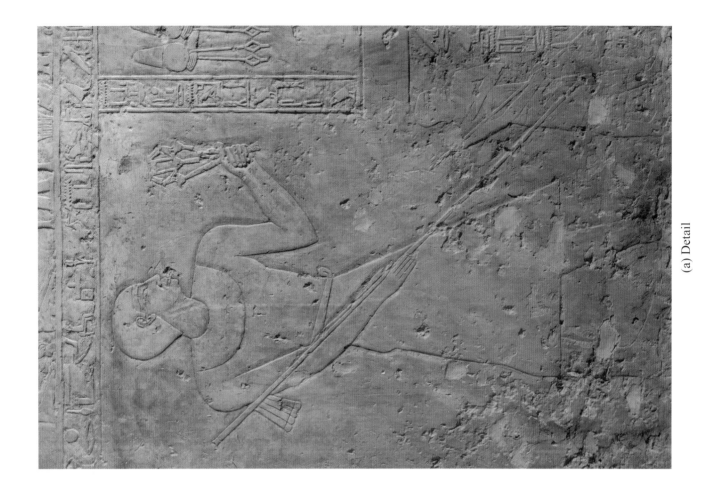

(a) Detail

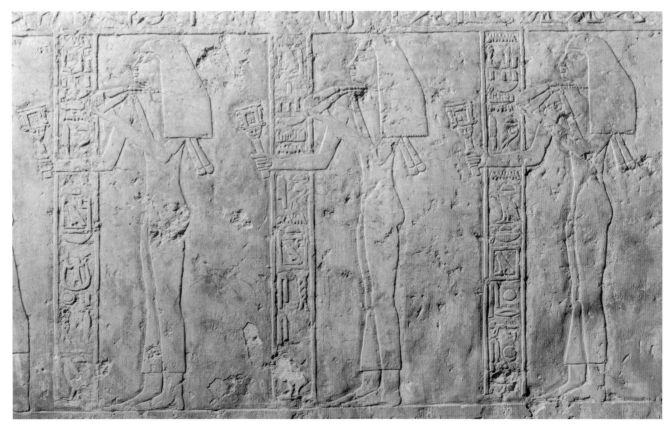

(b) Detail

Pl. 53. B2, west wall, south of statue recess (see pl. 88)

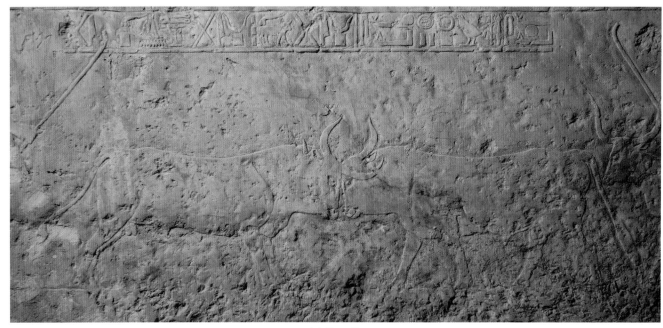

(a) Detail

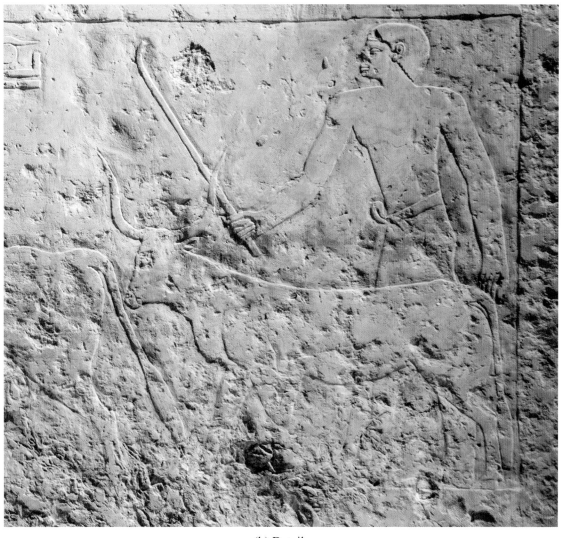

(b) Detail

Pl. 54. B2, west wall, south of statue recess (see pl. 88)

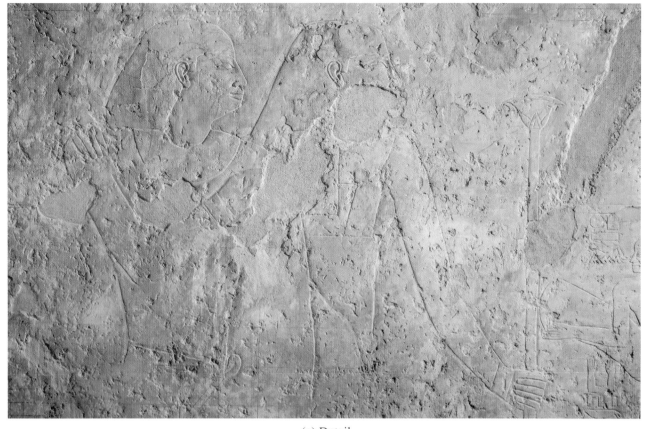

(a) Detail

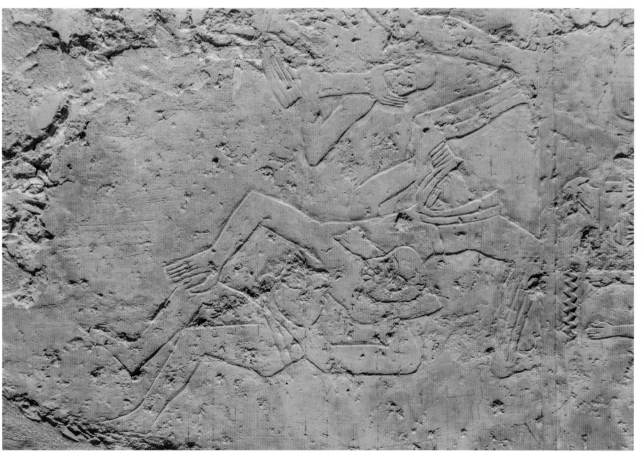

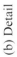

(b) Detail

Pl. 55. B2, north wall, west section (see pl. 89)

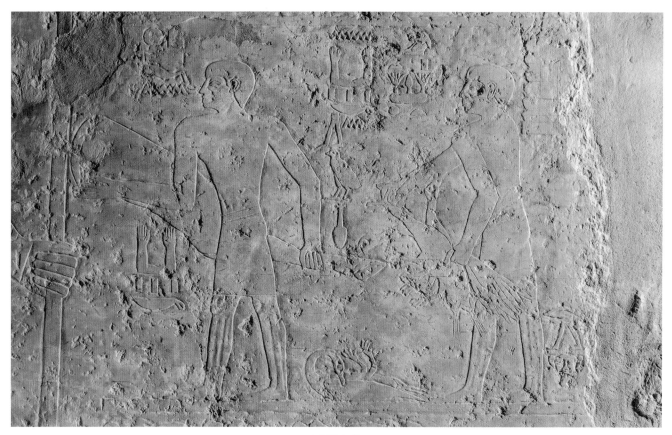

(a) Detail

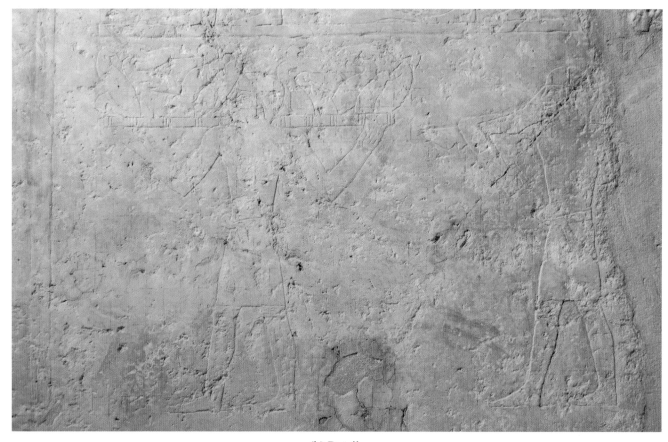

(b) Detail

Pl. 56. B2, north wall, west section (see pl. 89)

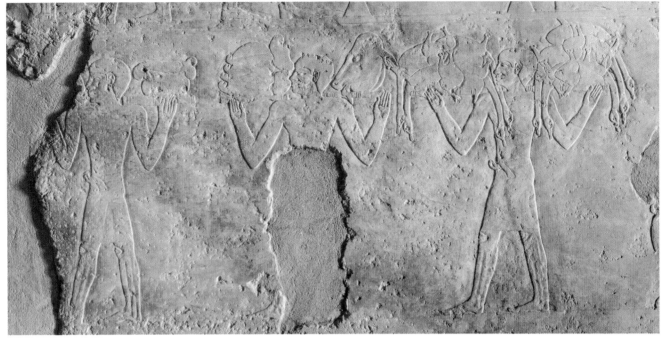

(a) Detail (see pls. 89-90)

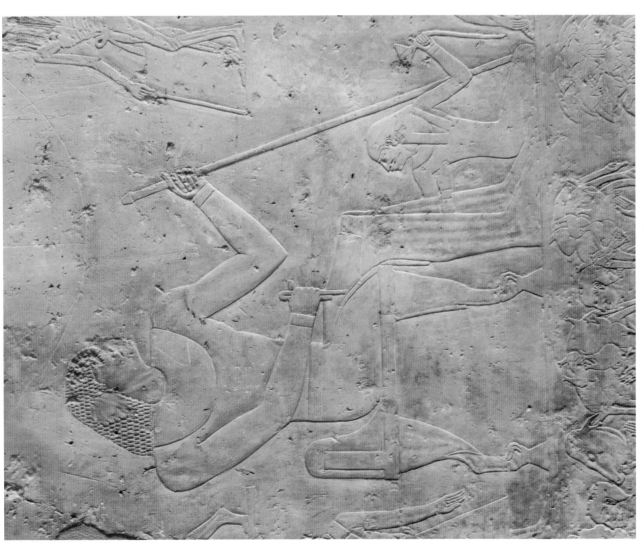

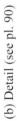

(b) Detail (see pl. 90)

Pl. 57. B2, north wall, west section

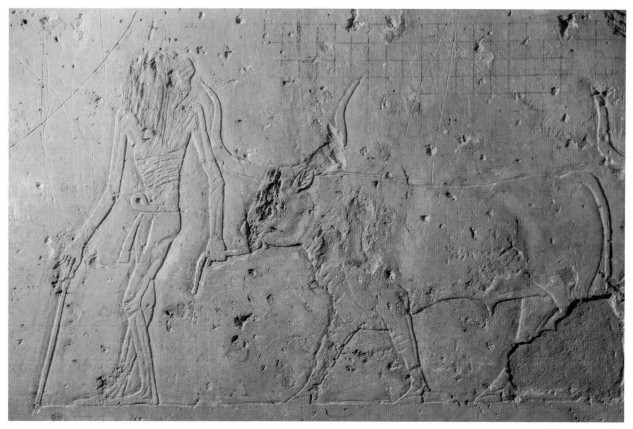

(a) West section, detail (see pl. 90)

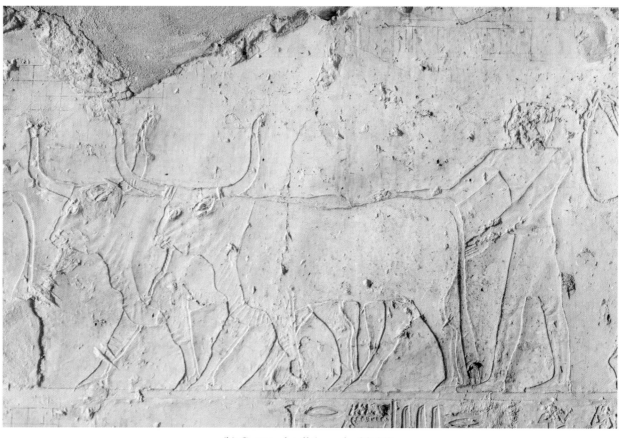

(b) Centre, detail (see pls. 90-91)

Pl. 58. B2, north wall

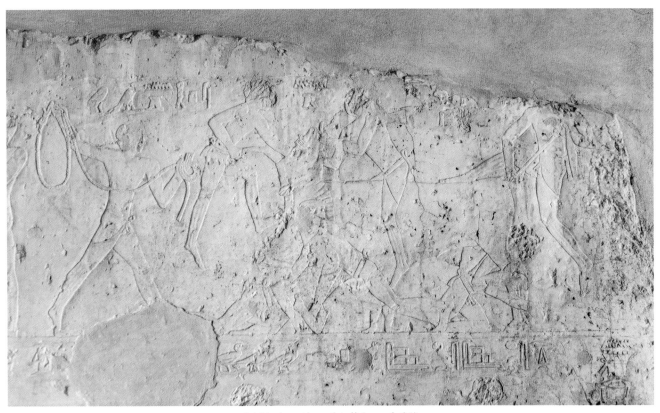

(a) East section, detail (see pl. 91)

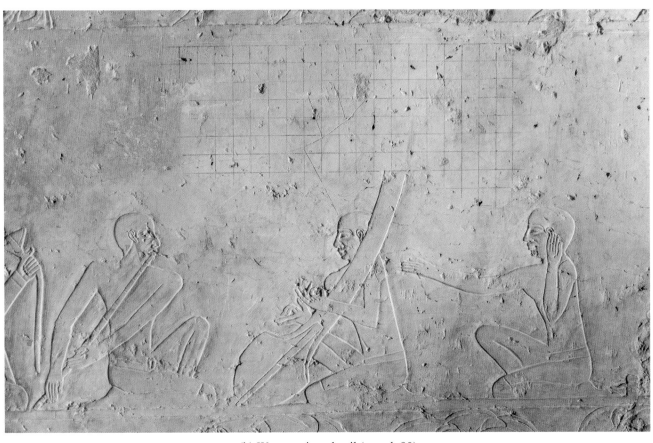

(b) West section, detail (see pl. 90)

Pl. 59. B2, north wall

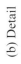

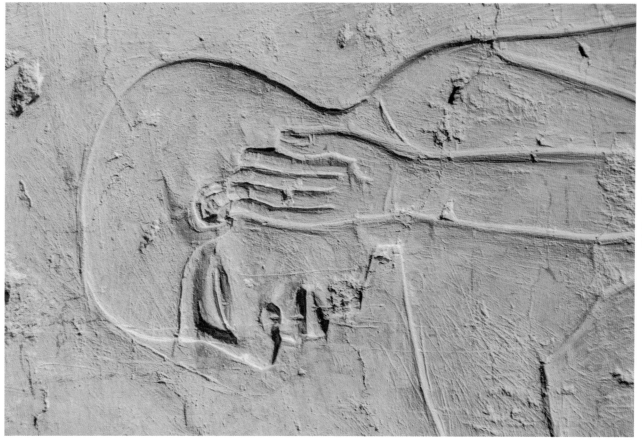

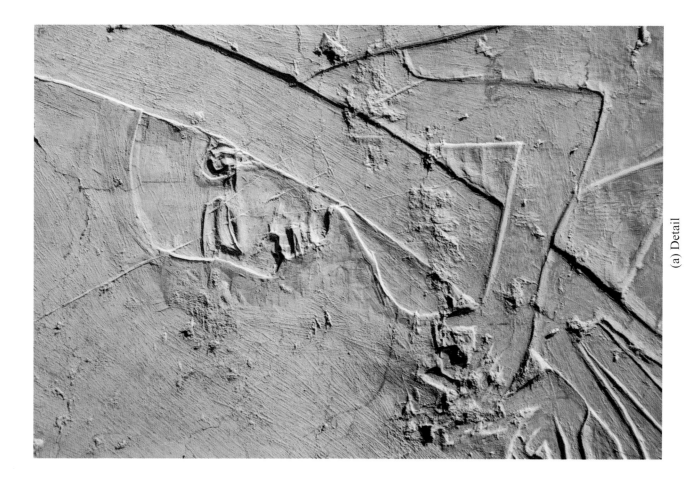

Pl. 60. B2, north wall, west section (see pl. 90)

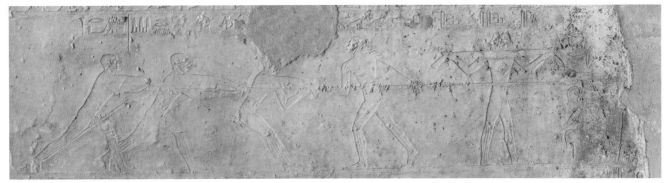

(a) Centre, detail (see pls. 90-91)

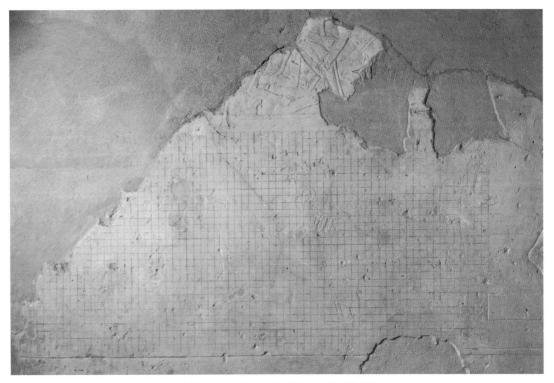

(b) East section, detail (see pls. 91-92)

(c) East section, detail (see pls. 91-92)

Pl. 61. B2, north wall

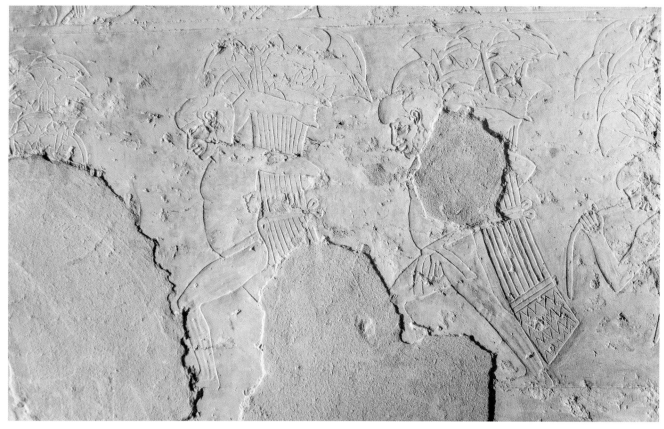

(a) Detail (see pl. 90)

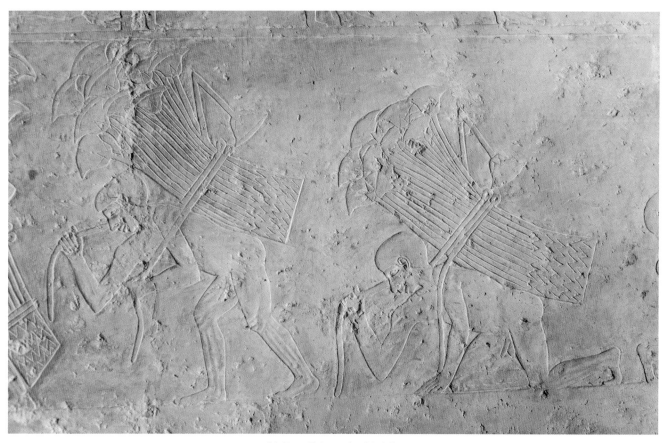

(b) Detail (see pls. 90-91)

Pl. 62. B2, north wall, west section

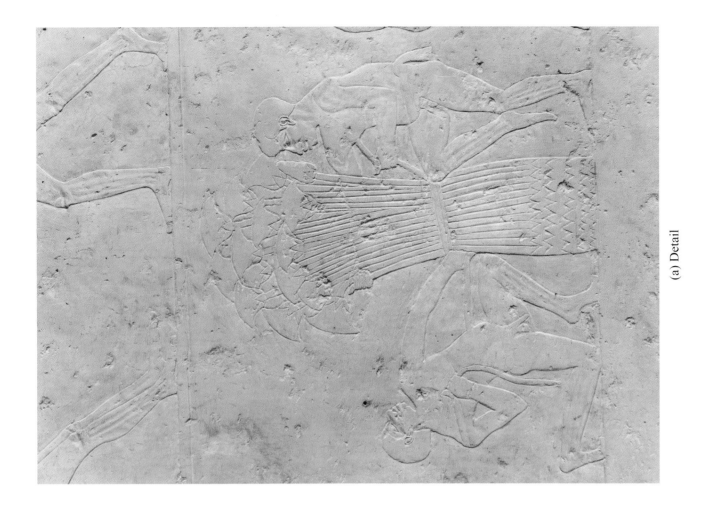

(a) Detail

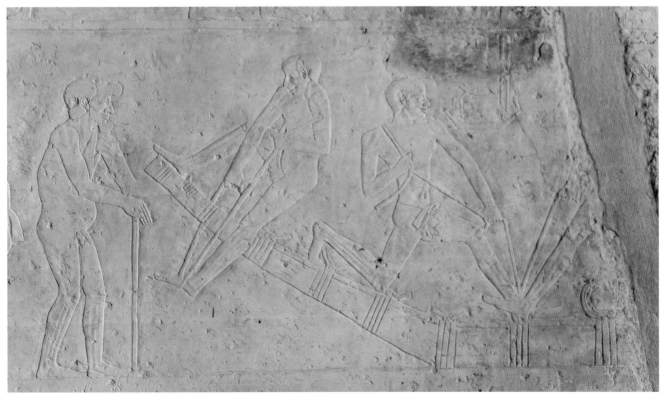

(b) Detail

Pl. 63. B2, north wall, east section (see pl. 91)

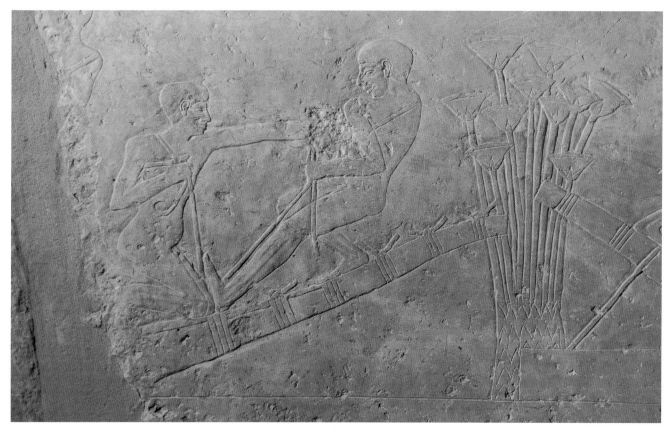

(a) Detail (see pl. 91)

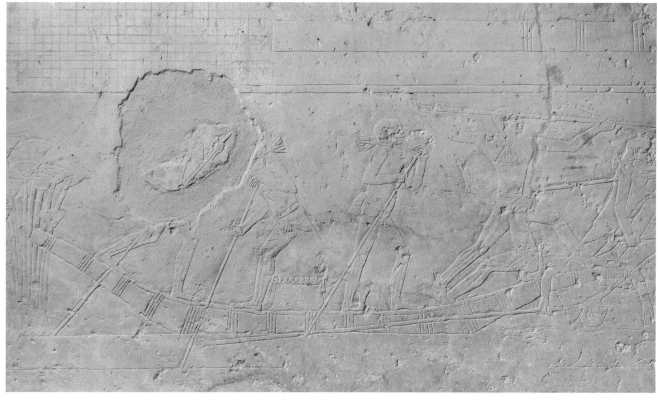

(b) Detail (see pl. 92)

Pl. 64. B2, north wall, east section

(a) Detail

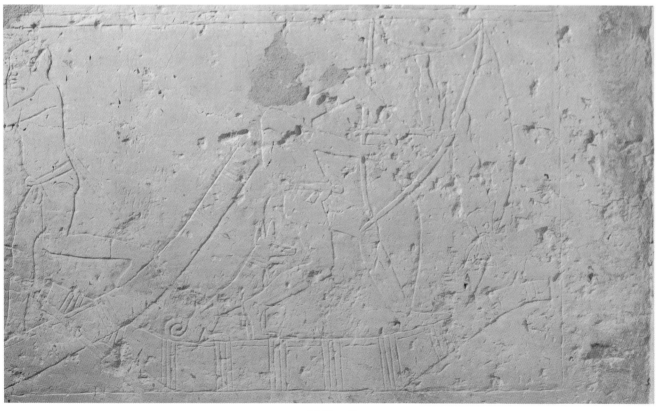

(b) Detail

Pl. 65. B2, north wall, east section (see pl. 92)

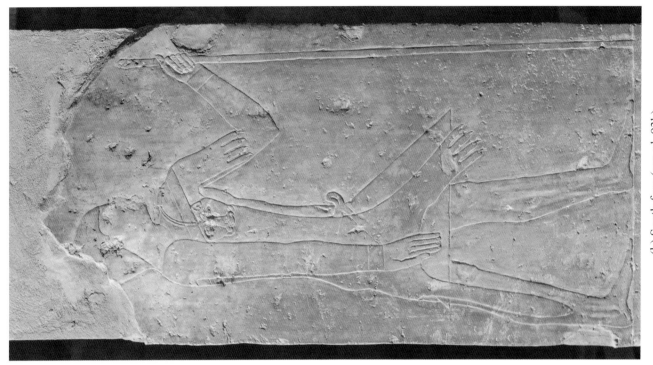

(b) South face (see pl. 93b)

(a) East face (see pl. 93a)

Pl. 66. B2, north pillar

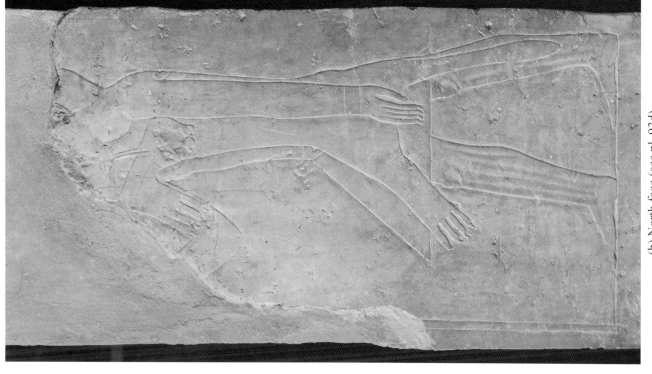

(b) North face (see pl. 93d)

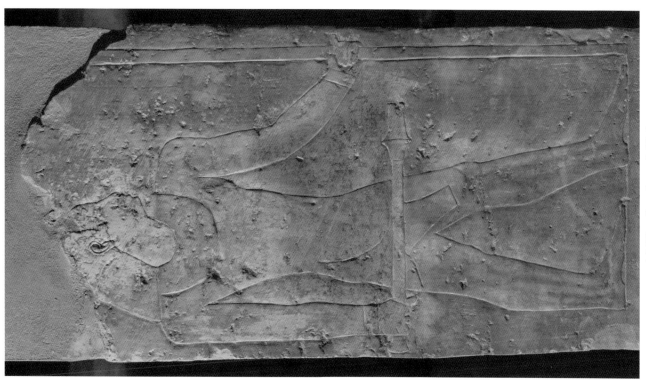

(a) West face (see pl. 93c)

Pl. 67. B2, north pillar

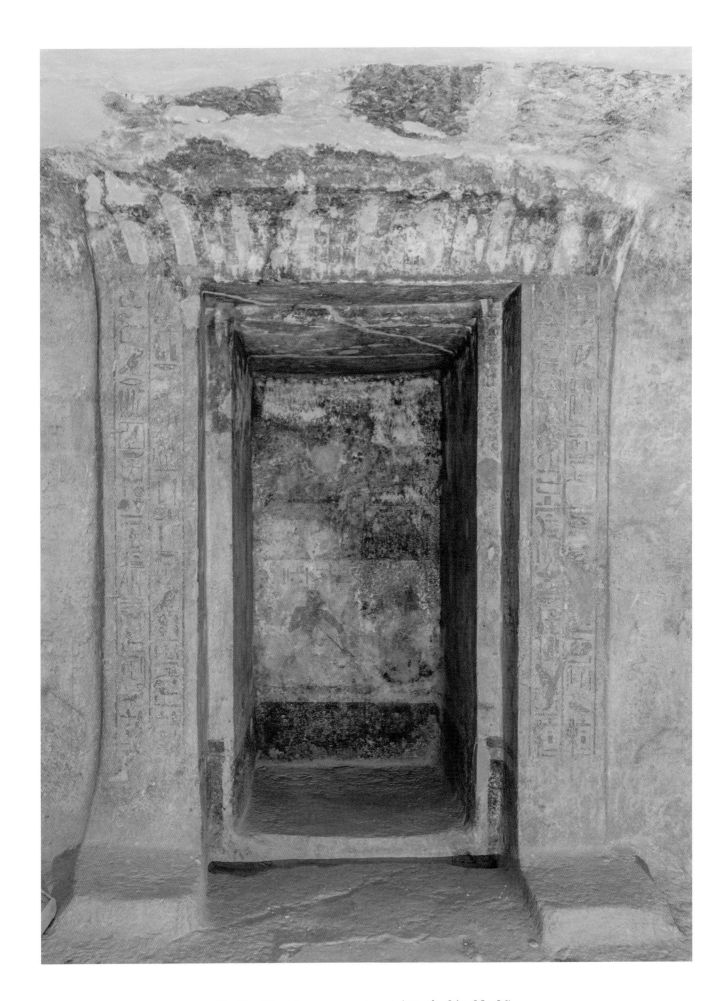

Pl. 68. B2, statue recess, entrance (see pls. 94a, 95c-96)

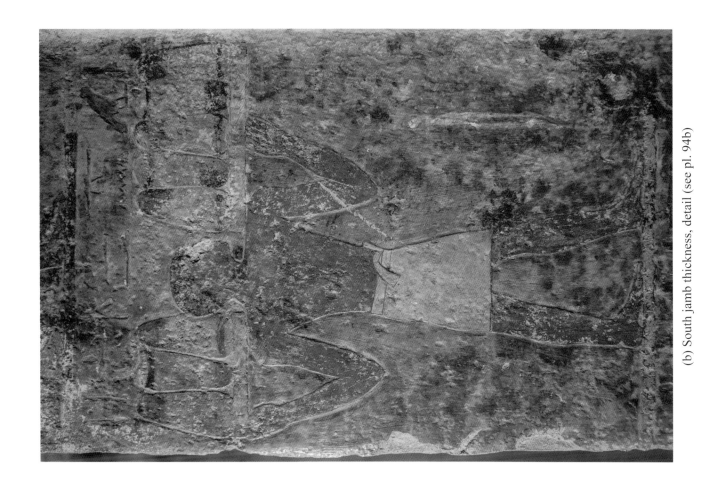

(b) South jamb thickness, detail (see pl. 94b)

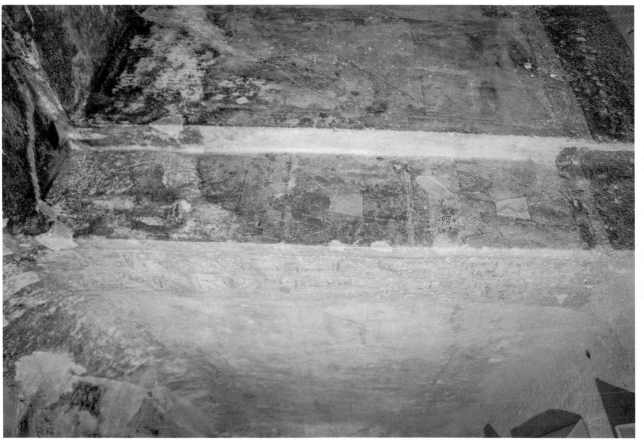

(a) Looking south (see pl. 94)

Pl. 69. B2, statue recess

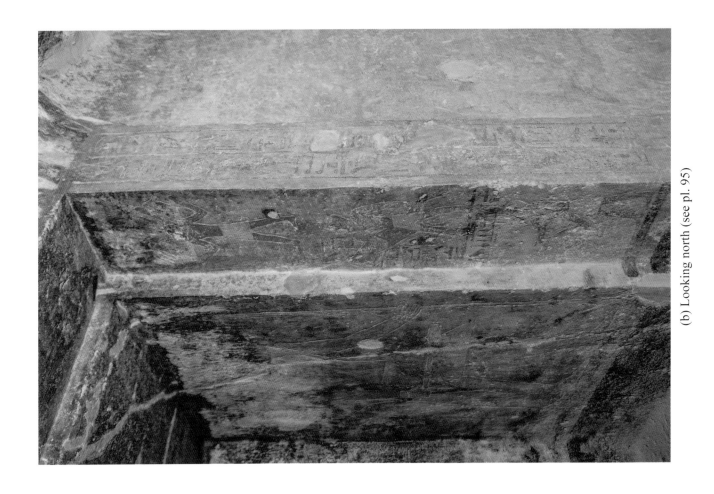

(b) Looking north (see pl. 95)

(a) South wall (see pl. 94c)

Pl. 70. B2, statue recess

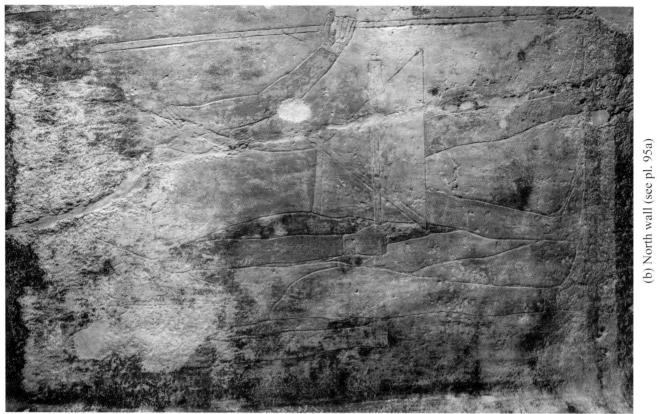

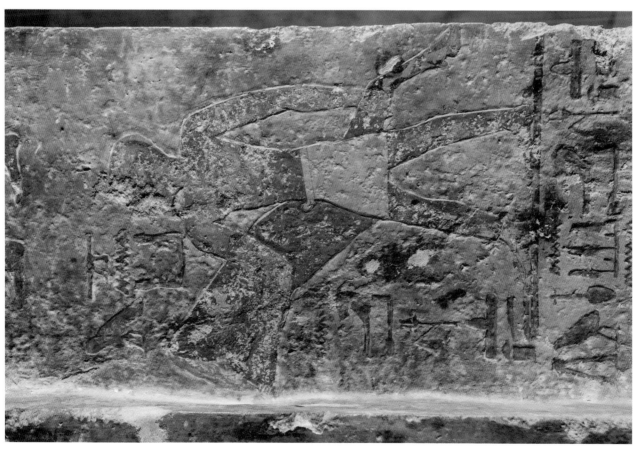

Pl. 71. B2, statue recess

(a) Detail

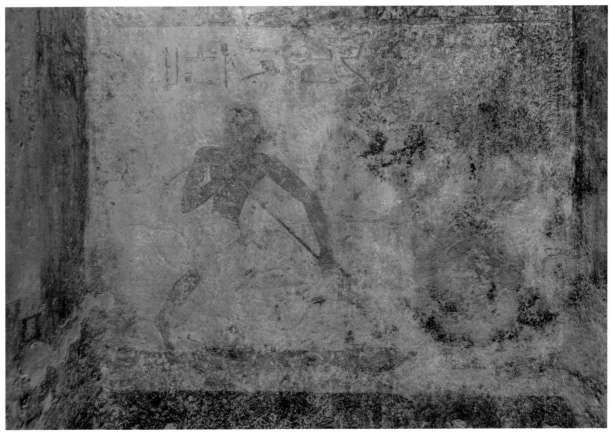

(b) Detail

Pl. 72. B2, statue recess, west wall (see pl. 96)